PAINTING *romantic*
COUNTRY
SCENES IN OILS

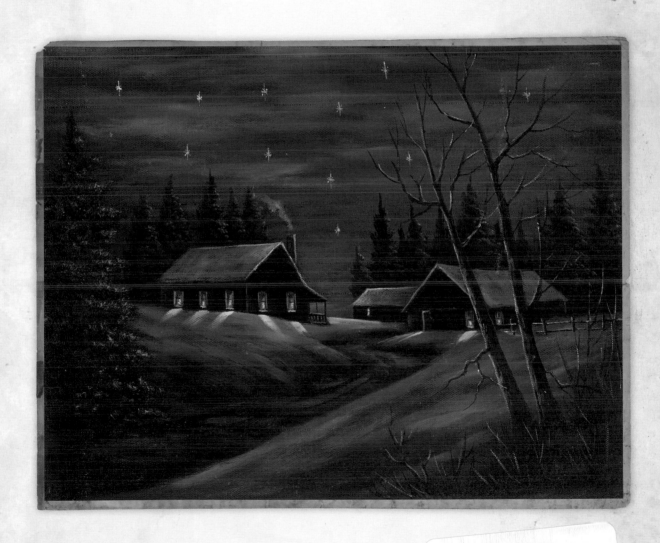

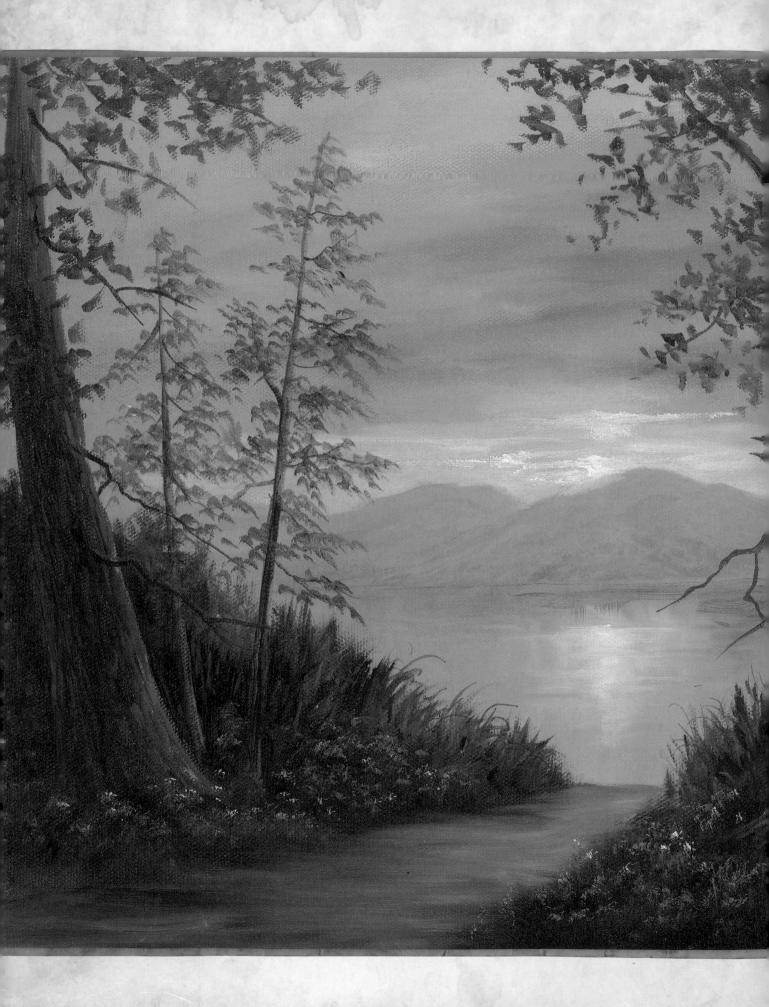

PAINTING *romantic* COUNTRY SCENES IN OILS

DOROTHY DENT

NORTH LIGHT BOOKS
CINCINNATI, OHIO
www.artistsnetwork.com

Painting Romantic Country Scenes in Oils. Copyright © 2009 by Dorothy Dent. Manufactured in China. All rights reserved. The patterns and drawings in this book are for the personal use of the decorative painter. By permission of the author and publisher, the patterns and drawings may be either hand traced or photocopied to make single copies, but under no circumstances may they be resold or republished. It is permissible for the purchaser to paint the designs contained herein and sell them at fairs, bazaars and craft shows. No other part of this book may be reproduced in any form or by any electronic or mechanical means, including information storage and retrieval systems, without permission in writing from the publisher, except by a reviewer who may quote brief passages in a review. The content of this book has been thoroughly reviewed for accuracy. However, the author and publisher disclaim any liability for any damages, losses or injuries that may result from the use or misuse of any product or information presented herein. It is the purchaser's responsibility to read and follow all instructions and warnings on all product labels. Published by North Light Books, an imprint of F+W Media, Inc., 4700 East Galbraith Road, Cincinnati, Ohio, 45236. (800) 289-0963. First Edition.

 Other fine North Light books are available from your local bookstore, art supply store or online supplier. Visit our Web site at www.fwmedia.com.

13 12 11 10 09 5 4 3 2 1

Distributed in Canada by Fraser Direct
100 Armstrong Avenue
Georgetown, ON, Canada L7G 5S4
Tel: (905) 877-4411

Distributed in the U.K. and Europe by David & Charles
Brunel House, Newton Abbot, Devon, TQ12 4PU, England
Tel: (+44) 1626 323200, Fax: (+44) 1626 323319
Email: postmaster@davidandcharles.co.uk

Distributed in Australia by Capricorn Link
P.O. Box 704, S. Windsor NSW, 2756 Australia
Tel: (02) 4577-3555

Library of Congress Cataloging in Publication Data
Dent, Dorothy
 Painting romantic country scenes in oils / by Dorothy Dent. -- 1st ed.
 p. cm.
 Includes index.
 ISBN 978-1-60061-165-0 (pbk. : alk. paper)
 1. Landscape painting--Technique. I. Title.
 ND1342.D4793 2009
 751.45'436--dc22
 2008035955

Edited by Jacqueline Musser
Designed by Clare Finney
Production coordinated by Matt Wagner
Photography by Christine Polomsky

ABOUT THE AUTHOR

Dorothy Dent began teaching decorative painting classes in 1972, soon growing her home studio into the nationally known Painter's Corner, Inc. shop and studio in Republic, Missouri. She began self-publishing painting instruction books in 1980 and has published twenty-nine titles since then. Her painting series, *The Joy of Country Painting*, appeared on the Public Broadcasting Service (PBS), and Bob Ross published two companion books. Her work has appeared in many of the decorative painting magazines, including *Decorative Artist's Workbook*. Besides *Painting Romantic Country Scenes in Oils*, Dorothy has also published *Painting Landscapes Filled With Light*, *Painting Four Seasons of Fabulous Flowers* and *Painting Realistic Landscapes With Dorothy Dent* for North Light Books. Dorothy continues to teach not only in her shop but all over the U.S., Canada, Japan, Argentina and Australia. Her schedule and art can be seen on her Web site, www.ddent.com.

METRIC CONVERSION CHART

To convert	to	multiply by
Inches	Centimeters	2.54
Centimeters	Inches	0.4
Feet	Centimeters	30.5
Centimeters	Feet	0.03
Yards	Meters	0.9
Meters	Yards	1.1

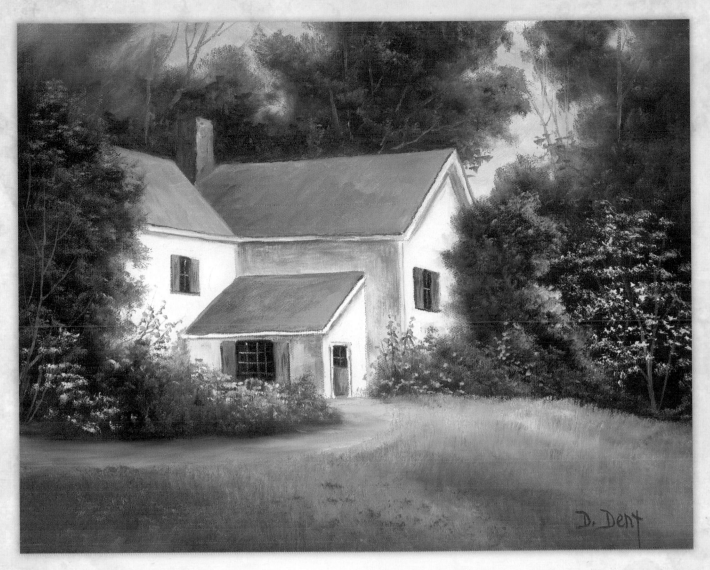

ACKNOWLEDGMENTS

A huge thank-you is in order to the editors at North Light with whom I have had the pleasure of working on this book. First, to Kathy Kipp, for inviting me to do the book, and to Jacqueline Musser, the editor I worked closely with, and to photographer Christine Polomsky for her skills with the camera as I repainted these paintings for the book. You are all wonderful to work with!

DEDICATION

I would like to dedicate this book to the many people who have given me so much help along the way. Without such help I would not be able to do what I do. A few deserve special recognition. First, thank you to my husband, D. A. Garner, who supports me in my painting, accompanies me to many seminars and conventions, and helps out at home as well. Thanks to my staff at Painter's Corner who keep my shop going whether I am there or not. Without these dedicated gals I don't know what I would do, so thanks to Celia Gable, my shop manager for more than thirty years. Thanks to Pam Brixey, who orders most of the supplies and keeps up the mail-order business. Thanks to Marcia Julian, who does our Web site and runs the giclee printing machines, and thanks to Becky Brown, who fills in when needed and traces most of the line drawings for conventions. Last, but not least, a big thank-you to all the students who have supported me for so many years by buying my teaching materials and attending countless classes and seminars. I hope you enjoy this book.

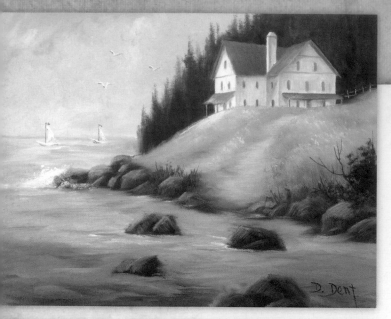

CONTENTS

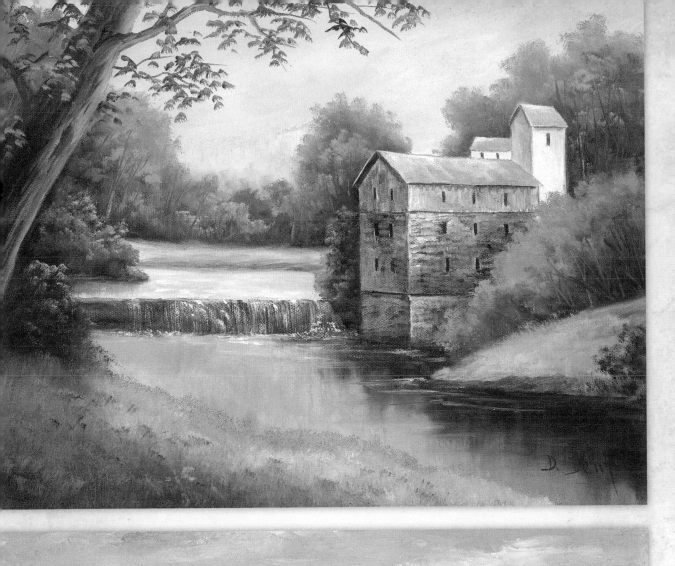

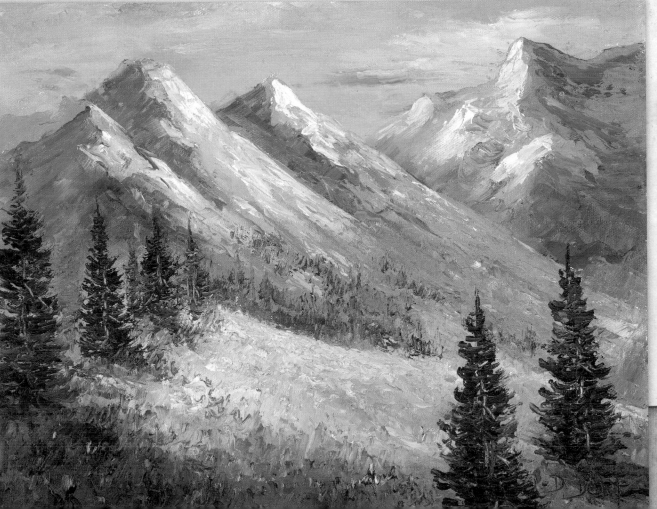

Fall on James River

INTRODUCTION

Oil painting has always been—and still is—my first choice of mediums. Oil paint has a rich look that I love. I also like the fact that it dries more slowly, and you have plenty of time to blend colors and push the paint around to make it do what you have in mind.

There are many different ways to paint, and artists use many different techniques. Thankfully there is no one way that is right. It is fun to experiment with different methods and find out what works for you. Artists often change their techniques as their work matures and they find new and better ways to apply paint to canvas. This keeps art creative and fun. My way of painting is only one way. I find that working in a clear-cut, step-by-step approach makes it easier to teach as well.

Although there are many different techniques in painting, as an artist, you should still keep in mind the basic elements that make a painting work. Color values of light and dark are a must for a painting to be interesting. The contrast of values is what gives a painting dimension. A painting without dark, medium and light values is flat, has no depth, and will be of poor quality. The artist must also balance the objects in the painting so it doesn't look too "heavy" on one side or the other. Every painting should have a center of interest as well. These and other similar qualities are what you as an artist will strive to create as you paint.

This book is designed to teach you by copying, but you will also learn skills you can use if you choose to paint your own sketches. Or, if you are already doing your own work, you might pick up a new technique or approach that you enjoy working into your own paintings.

SURFACES & PREPARATION

SURFACES AND PREPARATION SUPPLIES

1. Stretched canvas: All ten paintings in this book are painted on stretched canvas sized 12″ × 16″ (30cm × 41cm). You can find these ready-made in craft or painting supply stores. Choose a smooth-surfaced canvas. Portrait grade is best.

Of course, you can paint landscapes on any surface as long as you prepare it correctly and make any necessary painting adjustments. Ask someone at your local craft or hobby store for advice.

2. Gesso: Stretched canvas comes with a gesso coating, but I apply additional coats for a smoother surface. It's nice for oils, but if you have a smooth, tightly woven canvas, it may not be necessary.

3. 2-inch (51mm) disposable sponge brush: Use this to apply the gesso.

4. Acrylic undercoat: It sometimes works well to apply a coat of an acrylic paint over the canvas before transferring the pattern. The color of the canvas will show through to some extent and add to the finished look. Also you will have covered all of the canvas with a color, so there will be no white, unpainted canvas showing through where you may have stretched out the oil color a bit thin. You may want to experiment by basecoating with other acrylic colors.

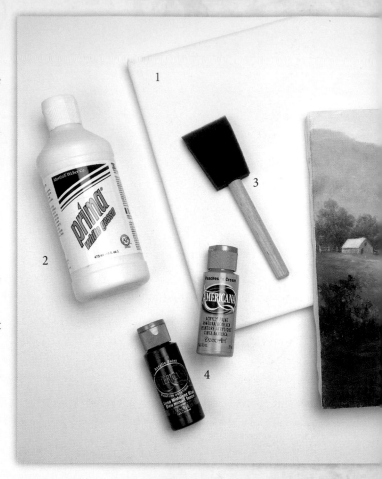

APPLYING GESSO

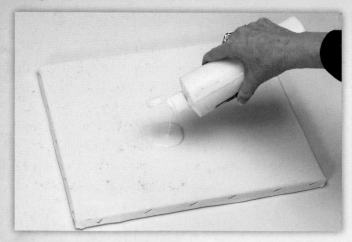

1. Pour it on.
Pour a puddle of gesso on the canvas.

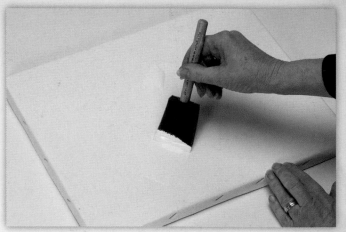

2. Spread it out.
Spread the gesso evenly on the canvas with a 2-inch (51mm) sponge brush. Clean the brush with soap and water.

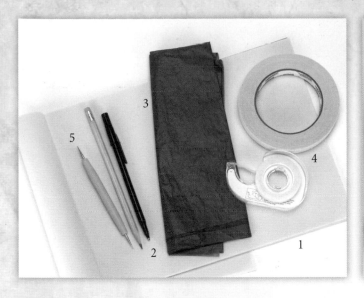

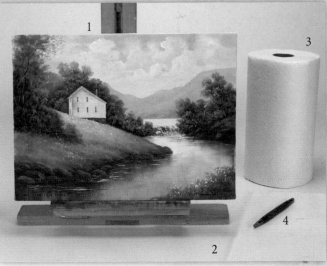

SUPPLIES FOR PATTERN TRANSFER

To transfer patterns onto your painting surface, you need these:

1. Tracing paper: This is a translucent paper onto which you trace patterns from the book.

2. Pencil or pen: Use one of these to trace your pattern.

3. Black graphite paper: This is a thin paper with a removable coating on one side that's used to transfer the traced pattern onto the painting surface.

4. Scotch tape or masking tape: Use one of these for holding the traced pattern in place while you're transferring it onto the painting surface.

5. Stylus: This tool works well for transferring the pattern. You may use a pen or pencil instead.

A FEW MORE GENERAL SUPPLIES

1. Table easel: An easel props up your canvas as you paint. A table easel allows you to sit while you work.

2. Palette paper: I prefer working with disposable palette paper. There are many types and brands available. Check the labels carefully and select palette paper that is appropriate for your paint (acrylic or oil).

3. Paper towels: You'll use paper towels for a variety of painting tasks. The more absorbent ones are best.

4. Wipe out tool: This is handy for lifting off oil paint to make corrections or for scratching out some wet sky where you want to put a tree.

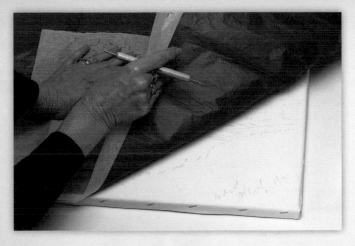

TRANSFERRING THE PATTERN

Once you've traced your pattern, position it on a gesso-covered canvas, being sure the canvas is dry. Secure the pattern to the canvas at the top only with masking tape or Scotch tape. With the dark side down, slip the graphite paper between the traced pattern and the canvas. Trace over the pattern lines with a stylus, pen or pencil. As you press down, the coating on the graphite paper will adhere to the canvas, creating a light reproduction of the pattern lines.

MATERIALS

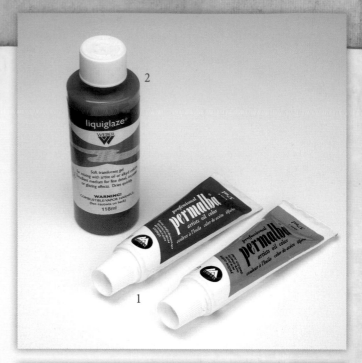

OIL PAINTS AND MEDIUMS

1. Martin/F. Weber Professional Permalba Artists Oil Color: I painted all the oil landscapes in this book with this paint, which is widely available in hobby, craft and art supply stores.

2. Martin/F. Weber Liquiglaze: Add a bit of Liquiglaze to your colors to help them spread easily.

BRUSHES AND RELATED MATERIALS

I used my own Dorothy Dent brand brushes to paint these projects. Make sure you have cleaning materials on hand.

1. Detail flat: This brush is equivalent to a no. 8 sable flat.

2. Foliage fan: This brush is equivalent to a no. 4 bristle fan.

3. Small background: This brush is equivalent to a no. 6 bristle flat.

4. Twiggy Liner: This brush is equivalent to a no. 1 sable liner.

5. Filbert: This brush is equivalent to a no. 4 filbert sable.

6. Odorless turpentine: Use this to rinse and clean your brushes both while you're painting and after you're finished.

7. Basin for odorless turpentine: Any plastic container will do.

8. Baby oil: Work baby oil into the bristles after you wash the brush in odorless turpentine. This will strip out any remaining paint.

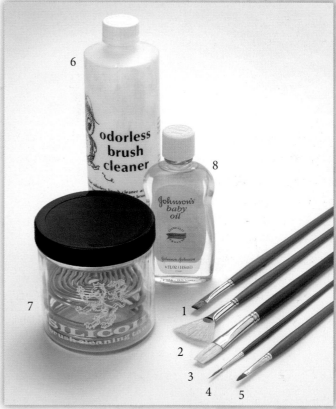

CARING FOR OIL BRUSHES

All brushes should be cleaned thoroughly after each painting session. Clean your oil brushes in odorless turpentine and then work baby oil into the bristles. Wipe out the baby oil until no trace of paint is left.

If you feel you must wash your oil brushes in soap and water, choose a product designed for this purpose. Don't use dish detergents or other soaps with softening agents.

After washing your brushes, be sure to pull them back to their original shapes. Allow them to dry thoroughly before painting with them again.

You cannot paint in oil with a brush that is damp with water because oil brushes, especially white bristle brushes, are made from real hair that soaks up water. This causes the brush to lose its shape and go limp. It's very difficult to get a water-soaked brush back to its original shape.

Oil brushes should be stored in a container that holds them securely in place so the points and chisel edges won't become bent or otherwise damaged.

If you have a brush that is out of shape from pushing against something, try dipping it quickly in almost-boiling water. Then pull the bristles back into their original shape and allow the brush to dry. This usually fixes the brush.

MARTIN/F. WEBER DAMAR VARNISH

For oils, I prefer Martin/F. Weber Damar Varnish. Whatever varnish you use, make sure it's appropriate for oil paint. A water-based varnish pools as you brush it over oil. The choice of matte, satin or gloss finish is up to you.

Permanent varnish, such as Damar Varnish, should not be applied until the paint has completely cured (dried). Premature varnishing can cause the paint to crack. Most manufacturers suggest waiting 6 to 12 months. Since I don't use heavy paint, I usually varnish after 2 or 3 months.

You may spray on a retouch varnish before an oil painting dries. Retouch varnish is meant to be painted over, so you can spray and paint several times. Just remember that retouch varnish isn't meant to do the job of permanent varnish.

WORKING WITH OILS

Oil paint stays wet for a long time, which gives you time to blend colors. You'll usually begin with the darkest values in any given area. Next you'll pick up the medium values, blending them into the edges of the dark so as not to lose either the medium or dark values. Last, you add a strong light value over the medium values.

If you lay down a light or medium basecoat, you'll find it very difficult to lay a strong dark on top. You'll pick up the wet light value beneath, and it will mix into the dark, weakening its value. Of course, there are exceptions to this order of proceeding from dark to medium to light, but this is generally how to work with oils.

Be aware that dark values in oils are very strong and can take over the medium and light values if they're applied too heavily. A rule of thumb is to apply dark values thinly and light values thickly.

SETTING UP AN OIL PALETTE

I use disposable palette paper (see page 11 under "A Few More General Supplies"). Look for paper with a slick, shiny surface so the oil paint won't soak in. Glass or hard plastic palettes are fine, but these have to be scraped and cleaned.

Set out your oils any way you find comfortable. Many artists like to lay out paints from light to dark. Whatever method you choose, you'll find that if you set up your palette the same way each time, you'll know where the colors are as you work.

Lay your colors on a side of your palette so you have room in the middle for mixing. Avoid laying your colors so close together that it's difficult to pick up one color without getting into neighboring colors.

COLOR

COLOR VALUE

Color value simply refers to how light or dark a color is. For example, you may refer to the color blue, but you haven't communicated whether the blue is a light or dark value until you describe it further. By adding white to the blue, you create a whole range of lighter blue color values. By adding a darker blue to the original blue, you get a darker range of blue color values. (Note that to darken values, you must stay within the same color family.)

Values are important in painting because they help you to place objects in perspective. They let us know where we are in the scene. When painting a landscape, we want to show depth. We want a feeling of being able to walk into the scene—a feeling of realism. The farther away objects are from you in a painting, the lighter in value they should be. The sky should be the lightest value in the painting because it's the farthest thing from you. As you come forward to distant hills or trees, the values should be darker than the sky and lighter than the hills or trees, which are closer to you. Dark and bright values seem close; the lighter values seem to recede. Be aware of values as you paint, and your work will look more professional.

Color values can also help you create a center of interest. Light against dark pulls your eyes to that spot. Pick out an area in your painting where you want everyone to look first. That area will be your center of interest. In that area, have some of the painting's darkest values close to the lightest values. That contrast pulls the viewer's eyes to the spot, helping to create a good focal point.

MIXING DIFFERENT VALUES OF GREEN

1. Create a dark green.
Pull out some French Ultramarine Blue. Then add a little bit of Cadmium Yellow Medium to create a very dark green.

2. Create a middle-value green.
Pull this dark green off to the side and add more Cadmium Yellow Medium and some Titanium White to make it lighter.

3. Create a light green.
Pull some of this lighter green to the side and add even more Cadmium Yellow Medium and Titanium White to make the green still lighter. You should have three values of green on your palette now: dark, medium and light.

4. Brighten the green.
If you add some Cobalt Turquoise to the lightest green you will get a brighter green.

TECHNIQUES

LOADING A PALETTE KNIFE FOR PAINTING

1. Roll the paint on the palette.
When loading the knife to paint with, hold the knife at an angle and roll out a section of paint on the palette.

2. Lift the paint off the palette.
When you lift up you'll have a roll of paint on the edge of the knife. Place this roll of paint against the palette and then use the flat of the knife to spread it around.

LOADING THE CORNER OF THE SMALL BACKGROUND BRUSH

1. Place the brush in the paint.
Place the edge of the brush in the paint and pull out.

2. Keep the paint on top of the bristles.
When you turn the brush over the paint is on top of the bristles and you can work with the corner to make small taps of color.

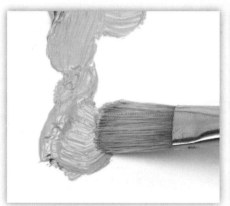

LOADING A FOLIAGE FAN BRUSH

1. Mix the colors.
Mix your colors with the corner of your brush. Here, I've mixed French Ultramarine Blue with Cadmium Yellow.

2. Keep the paint on top of the bristles.
When you turn the brush over, you'll see that the paint is on top of the bristles.

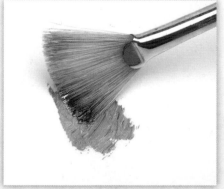

PLACING FOLIAGE WITH A FOLIAGE FAN BRUSH

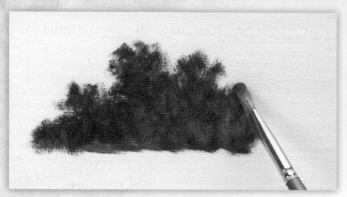

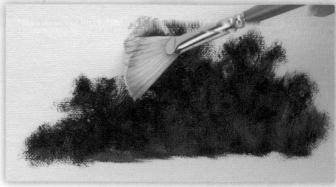

1. Place the foliage.
Scrub on a dark area of background foliage.

2. Place the first highlight.
Load the corner of the foliage fan brush and flip it so the paint is on top. Start the highlight just outside the dark basecoat color.

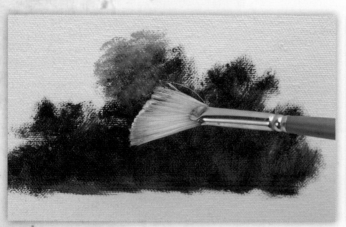

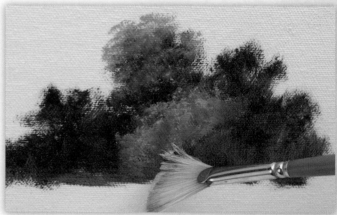

3. Blend the highlight.
Create a bright edge then let the color fade out by using less pressure on the brush as you move across the bush.

4. Place the second highlight.
Start another cluster of foliage a little ways over to pull out a separate cluster. Again create the bright edge and let the color fade back into the shadow.

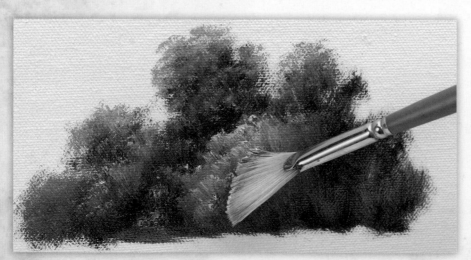

5. Add the brightest highlights.
Once you place all of your highlights you can go back and add more highlights to the brightest edges.

CREATING LEAVES WITH A FILBERT BRUSH

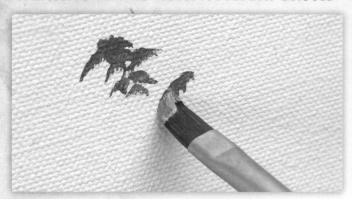

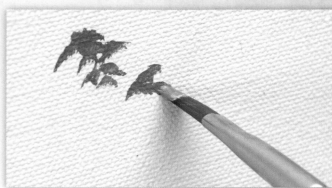

1. Lean the brush to the left.
Load a filbert brush with paint. Place the tip of the brush against the canvas and then lean the bristles to the left.

2. Lean the brush to the right.
Then rock the bristles back and lean them to the right. This makes a small, upside down "v" shape that resembles a leaf.

CREATING LEAVES WITH THE DETAIL FLAT BRUSH

When I use a detail flat to make leaves, I roll the brush against my middle finger so the strokes go on the canvas at different angles. This technique keeps your leaves from looking like polka dots because the rotation of the brush puts the bristles in a different direction each time.

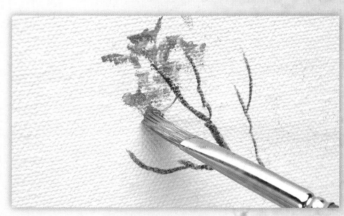

1. Dab on color.
Make a few dabs with the brush.

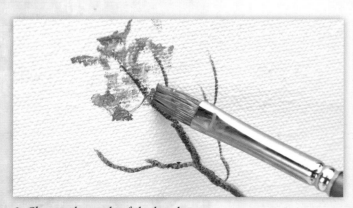

2. Change the angle of the brush.
Roll the brush a little on your middle finger so the bristles are at a different angle. Make a few more dabs, then roll the brush again so the bristles are at another angle.

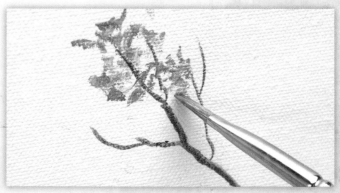

3. Dab on more color.
Make a few more dabs with the bristles at this new angle. Continue until you are satisfied.

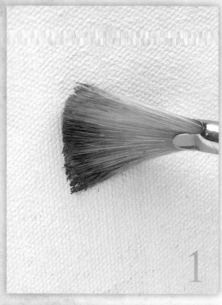

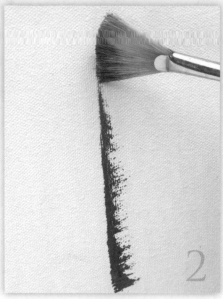

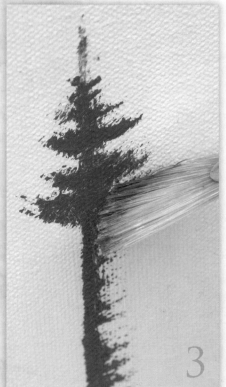

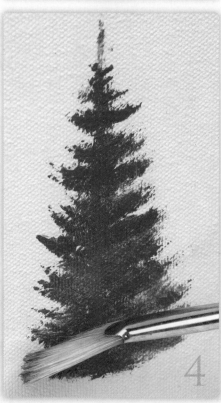

MAKING A PINE TREE

1. Load and position the brush.
Load a foliage fan brush with paint. Place the brush against the canvas so the bristles are perpendicular to the bottom of the canvas and move the brush upward to create a vertical line.

2. Create the center line.
Once the tree reaches its proper height, pat up a bit with the bottom few hairs of the brush using only the corner. This will create the peak.

3. Add horizontal branches.
Once the center is established, drop down a little from the peak and pat out and then in, starting in the center and staying on the corner of the brush. This will create the branches of the tree.

4. Fill out the shape.
Work all the way down the tree, creating shape with small taps of the brush.

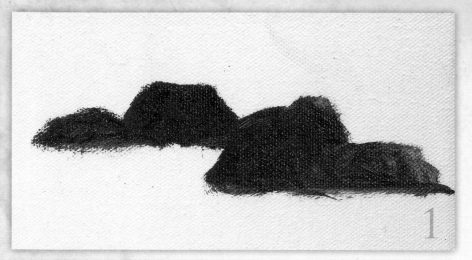

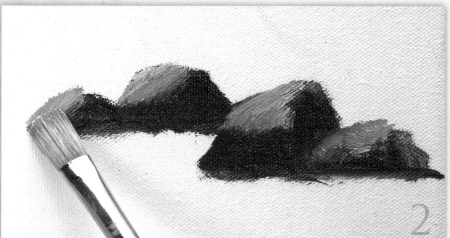

PAINTING ROCKS

1. Basecoat the rocks.
Base in the dark forms of some rocks.

2. Add the light side.
Create a light side on the tops of the rocks. The light side can be irregular shapes.

3. Add the dark side.
Barely indicate color for the dark side so it shows a bit of shape. Don't use as much color on this side as you did on the light side or you won't have enough contrast between the two sides and the rock will lose its shape.

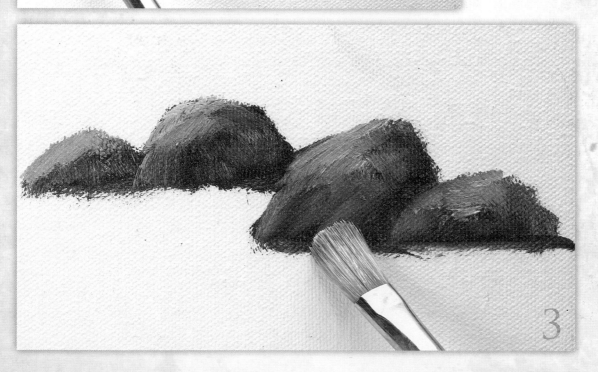

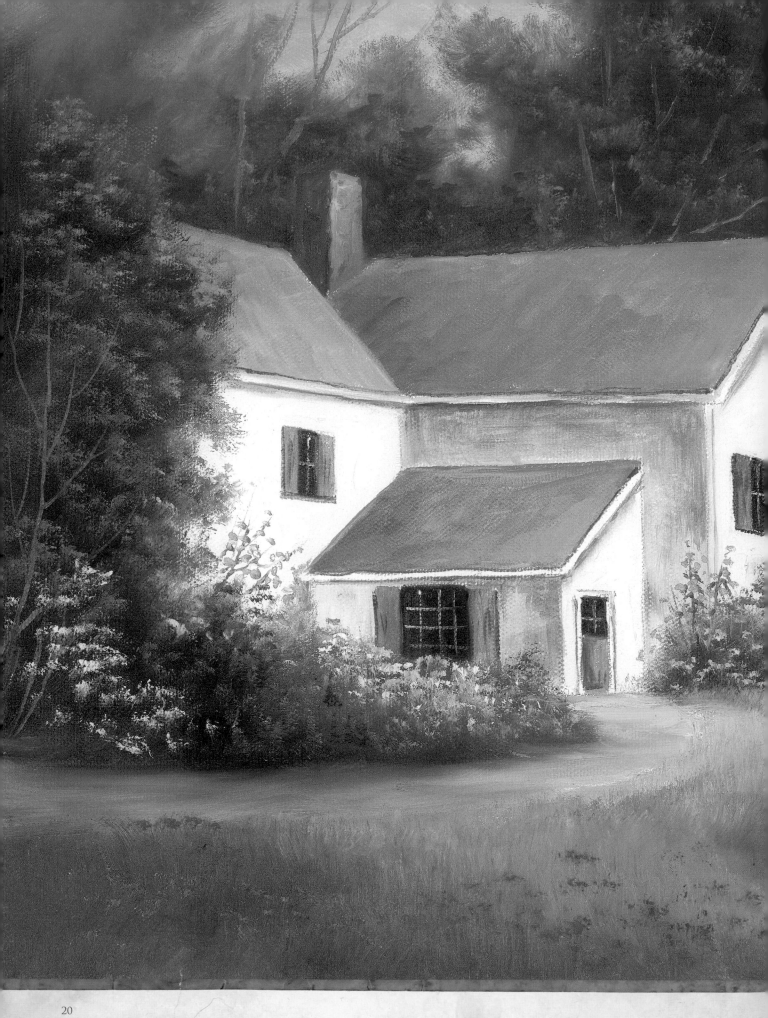

D. Dent

CRICKET HILL COTTAGE

I love little cottages tucked into foliage and flowers. They have a homey, cozy look that makes me want to spend some time there.

I did this painting from a photo I took of the home I was staying in while teaching in Canada. I added more flowers and shrubs than were actually there. Don't be limited by what is in the photo you are using for your inspiration. Use your artistic license to add or delete elements to make the painting better and more interesting.

As I paint a scene such as this, I like to pretend I am actually on site, sitting in the yard, smelling the flowers and sipping iced tea as I apply paint to canvas.

> I'd love to live in a cottage
> With flowers all up to my door
> With bunches of roses and zinnias,
> Some iris, and daisies galore.
>
> I'd bake cookies and cakes in the morning,
> Set the table for you and for me
> We'll gather a bouquet from the garden
> When you come in the evening for tea.
>
> D. Dent

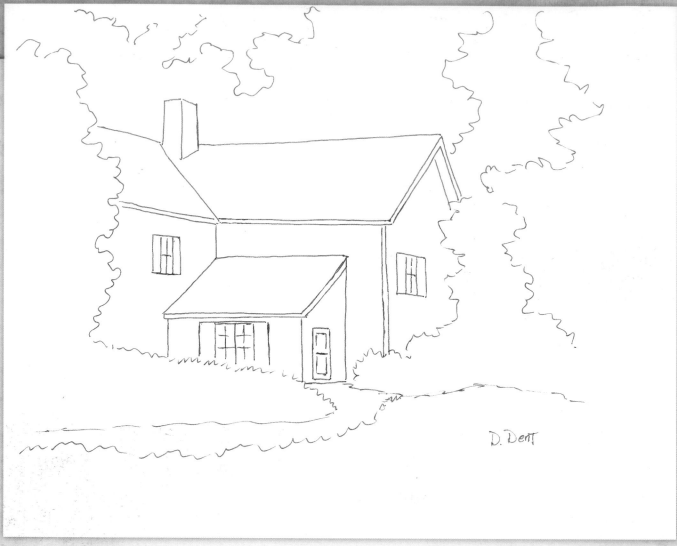

D. Dent

This pattern may be hand-traced or photocopied for personal use only. Enlarge at 200% to bring it up to full size.

Materials List

Surface
Stretch canvas, 12" × 16" (30cm × 41cm)

Dorothy Dent Brushes
Small background (no. 6 bristle flat)

Detail flat (no. 8 flat sable)

Small detail flat (no. 4 flat sable)

Filbert (no. 4 sable filbert)

Foliage fan (no. 4 bristle fan)

Twiggy liner (no. 1 sable liner)

Medium
Martin/F. Weber Liquiglaze

Other Materials
Odorless turpentine (for rinsing and cleaning brushes)

Rinse basin

MARTIN/F. WEBER PROFESSIONAL PERMALBA ARTISTS OIL COLORS

Brilliant Yellow Light

Cadmium Orange

Cadmium Red Light

Cadmium Yellow Medium

Dioxazine Purple

French Ultramarine Blue

Paynes Gray

Quinacridone Red

Titanium White

Seeing With the Artist's Eye

What attracts most people to a painting is color and light. I love this piece because of the light on the building and the beautiful colors in the flowers. I have noticed that if I add flowers to a painting it becomes a very popular piece.

Work on grouping colors of flowers for a realistic look. Many times students make flowers too stiff looking or the flowers have a dotty look. The flowers need to look set into the shrubbery around the shrubs.

Be aware of light and shadow and emphasize these at the corners of a building. Note that the dark side of the building is slightly darker as it comes into the corner for greater contrast with the light side of the building.

I like to paint more light on the grass where it is closer to the center of interest. In this painting the center of interest is the right side of the building. Note that the brightest foliage is also grouped closer to the right side of the house. Other areas of green on the trees or grass are darker in value.

You may have a photo that you would like to paint as it interests you, but you realize it needs more light to be eye-catching. Don't be afraid to add more definite light and dark values even though they are not in the photo. Sprinkle in some lovely flowers and watch the painting pop into life!

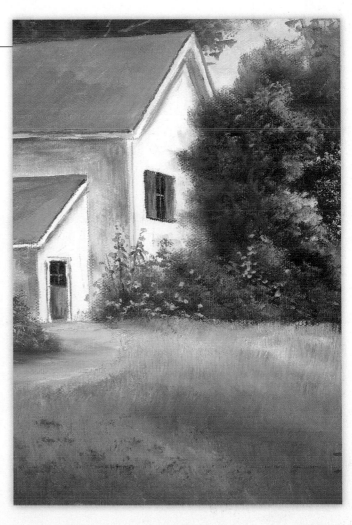

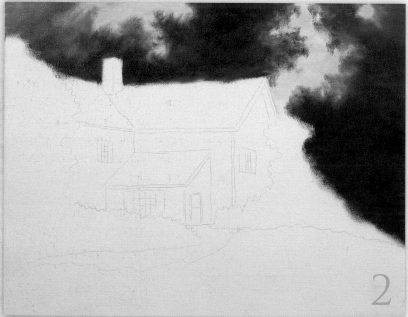

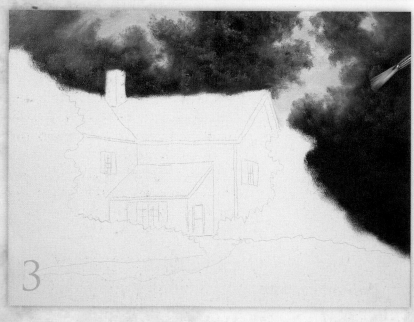

1. BASE THE SKY

On the small background brush, pick up Titanium White + a touch of French Ultramarine Blue and fill in the sky areas. Overlap a little bit into the trees. Vary the color a bit between more white and more blue to create a cloudy look.

2. BLOCK IN TREES

Block in the background trees using the small background brush. The dark-value trees are Paynes Gray + French Ultramarine Blue + a very little bit of Cadmium Yellow Medium. Use very little yellow as this is a very dark green. Soften the edges of the trees out over the edges of the sky so it has a soft, irregular look. Don't stop abruptly at the sky or you will have a distinct line.

Work carefully around the house so you don't lose the transfer lines. You can add a touch of Titanium White to the mix every once in a while to vary the value.

3. HIGHLIGHT THE TREES

Use the corner of the foliage fan brush to place highlights on the foliage. Create a softer, lighter-value green by mixing Cadmium Yellow Medium + French Ultramarine Blue + Titanium White for the highlight. Use the corner of the brush only and keep the paint on the top of the bristles by flipping it over after you load it (see page 15). Tap the color on with just the corner of the brush. Don't lose all of the basecoat. You still want to see some of the dark foliage. Most of the highlight is placed on the foliage around the house and toward the upper right. Don't place too much highlight in the lower right because a flowering white tree will be there.

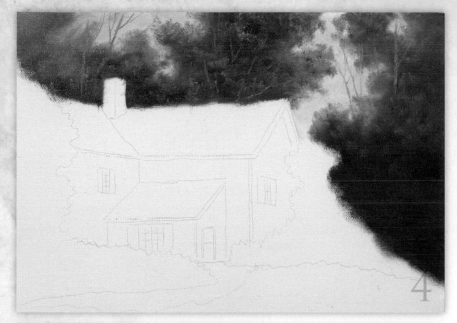

4. ADD LIMBS

Add a few limbs to the trees using the twiggy liner. Mix French Ultramarine Blue + Cadmium Orange + Titanium White for the limb color. Thin the paint with turpentine instead of medium. These are small limbs that you would see at the tops of trees. Skip around with where you place the limbs and let some limbs travel off the edge of the canvas and others travel over into the sky area.

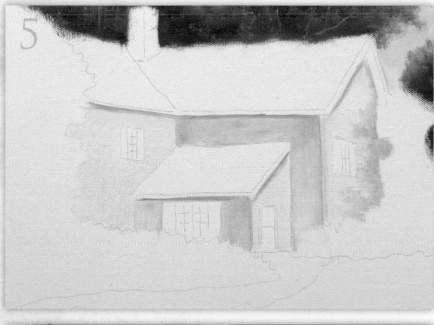

5. BASECOAT THE HOUSE

Switch to the detail flat brush to paint the house. The light sides (all of the right-facing sides) are Titanium White + a touch of Brilliant Yellow Light to create a warm, sunny look.

The shadowed sides are Titanium White + a small touch of Paynes Gray + a small touch of Dioxazine Purple to create a purplish gray color. Place this same shadow color under the eaves on the light sides of the house and around the bush that will be placed against the house to create the bush's cast shadow. Darken the shadow directly under the roof edge.

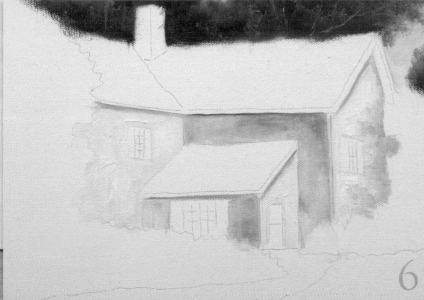

6. ADD SHADOW AND CONTRAST TO THE HOUSE

Still using the detail flat, strengthen the shadows on only the shadowed side of the house by adding a bit of the dark green foliage mix from Step 2 + Paynes Gray + Cadmium Yellow Medium to the wall. You don't want to add too much green, just enough to reflect the color from the bushes surrounding the house.

With a clean brush, add additional Titanium White rather thick to brighten the color on the light side of the house. It's OK to see brush strokes in the Titanium White as it will look like stucco.

Take the edge of the detail flat brush and create a corner board on the right side of the house with just a touch of the shadow color set to the inside of the corner.

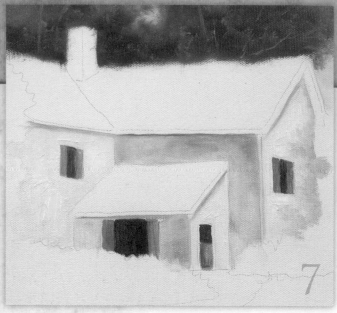

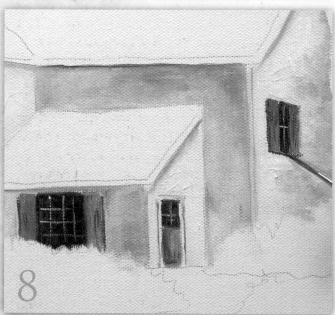

7. PLACE THE WINDOWS AND DOOR

Switch to the filbert brush and mix Paynes Gray + a touch of Dioxazine Purple to paint the windows. Don't paint the shutters. Only paint what would be the glass part of the window. Paint the top part of the door so it looks like there is glass in the top section.

Clean the brush and paint the shutters with a green mixed from Cadmium Yellow Medium + French Ultramarine Blue + a touch of Titanium White to soften the color. Use this color to paint the bottom section of the door as well.

8. DETAIL THE WINDOWS AND DOOR

Detail the windows with a twiggy liner brush. Load the brush with pure Titanium White. The two top windows are divided once through the middle going vertically and once through the middle going horizontally. Divide the window in the door into four panes as well. The picture window has three horizontal lines and three vertical lines.

Pick up a little Paynes Gray on the twiggy liner and add a shadow line beneath all of the windows. Also sketch a frame around the door by drawing the line around the outside of the door to make it look set into the house. You might want to add a line of dark value along the edge of the shutters to set them back against the house. A few little dark streaks on the shutters themselves will add texture and detail.

9. BLOCK IN THE ROOF

Switch to the detail flat to paint the roof. For the two darker sections of roof (those on the right side of the house) mix Titanium White + a touch of Paynes Gray + a touch of Cadmium Red Light to create a purplish gray. The roof isn't very dark so add a lot of Titanium White to the mix.

There is a variation of color across the roof so add more Paynes Gray toward the bottom and where the two sections of roof meet. Refer to the photo to see where to place the darker values. Follow the general slope of the roof and use a little medium to move the paint around. Come down to the fascia board but do not paint it out.

The light side of the roof is based with a little more Titanium White in the roof mix. Add a touch of Cadmium Orange to the mix toward the bottom of this lighter section of roof. Add a touch of this color to the edge of the darker roof.

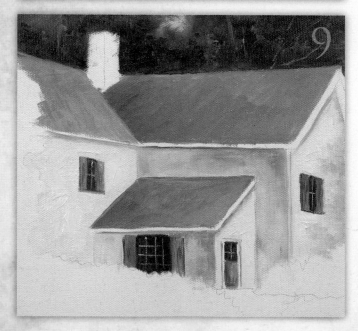

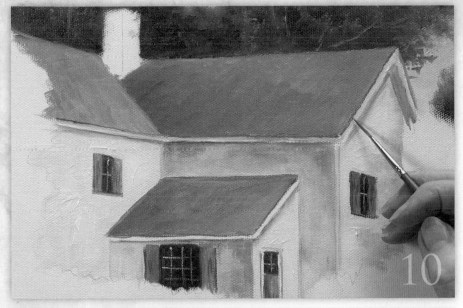

10. PAINT FASCIA BOARDS

Paint the fascia boards with the small detail flat. On the shadow side add a touch of the roof color to Titanium White. On the light side use a whiter white. Paint the underside of the gable roof with Titanium White + Paynes Gray so it looks like an overhang.

You may want to deepen the shadows beneath the fascia board with a little more Paynes Gray.

Use a twiggy liner to run a small shadow line of Titanium White + Paynes Gray between the roof and the fascia board.

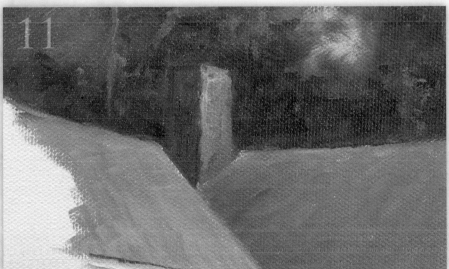

11. ADD THE CHIMNEY

Use the filbert brush to paint the chimney. Mix Cadmium Red Light + Paynes Gray to paint the left side (which is the darker side). Add a touch of Brilliant Yellow Light to this mixture and paint the right side of the chimney (the lighter side). To create some brick-like texture, highlight with some extra Brilliant Yellow Light on the right side.

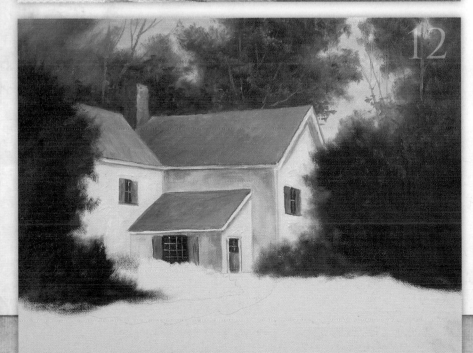

12. BLOCK IN THE BUSHES

Switch to the small background brush to block in the large bushes surrounding the house. Paint the bushes with Paynes Gray + a tiny touch of Cadmium Yellow Medium. The tops of the bushes need to be soft and have an irregular shape. Soften out the upper edges by using less pressure on the brush. Let the left side of the bush on the right of the house become part of the shadow on the house so there is no hard line.

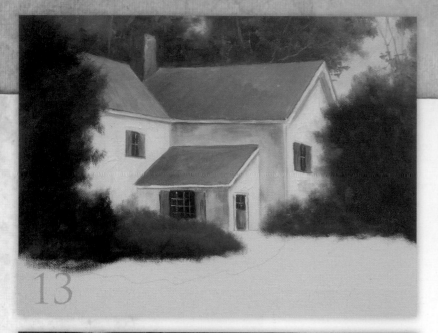

13. BASE THE SMALL FLOWER BUSHES

Using the small background brush, base in the small flower bushes in front of the house with a lighter green (Paynes Gray + more Cadmium Yellow Medium). Darken the bushes as they move away from the house and toward the path by picking up more Paynes Gray.

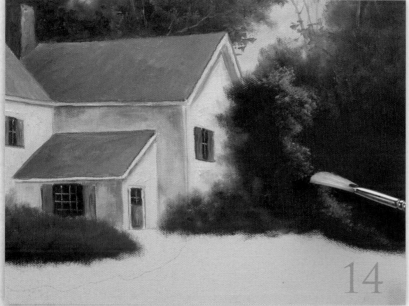

14. HIGHLIGHT THE BUSHES, PHASE 1

Begin to tap in highlights on the bushes using the corner of the foliage fan brush. Mix Cadmium Yellow Medium + French Ultramarine Blue + a touch of Titanium White to create the highlight color. Start by highlighting the bush closest to the house. When you apply the highlight, first create the edge of the bush using an irregular pattern as shown in the photo.

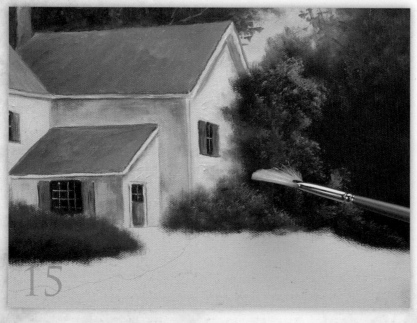

15. HIGHLIGHT THE BUSHES, PHASE 2

Once you create the highlight edge, place some highlights in the center of the bush but don't lose all of your dark value. Use less pressure on the brush for the center highlights. Don't allow the highlight to come all the way to the wall of the house. Preserve the shadow along the wall to give the bush more shape. (See page 16 for additional instruction on highlighting foliage.)

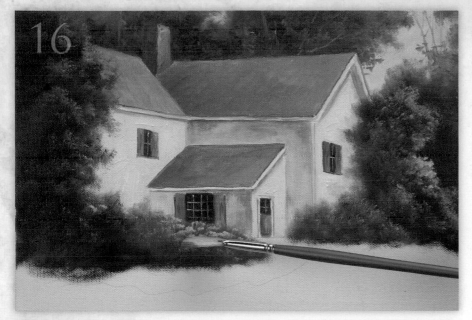

16. HIGHLIGHT THE LEFT-SIDE BUSHES

Highlight the bush on the left side of the house following the instructions in steps 14 and 15, but don't add as much highlight color because there will be a lot of flowers on this bush.

Also, use the foliage fan brush to place some strong Cadmium Yellow Medium + Brilliant Yellow Light in the light-value bushes beneath the picture window. This paint should be heavier. Let this highlight fade out as you move down closer to the path.

17. PAINT THE PATH

Switch to the small background brush to paint the path. Mix a soft peach color of Titanium White + Cadmium Orange + Cadmium Red Light. Be sure there is a lot of Titanium White in this mixture. Start the path right under the door and use horizontal strokes to move the paint. Catch some of the green on the left side of the path to create a shadow. As you start to move off the edge of the canvas, pick up even more of the green and even some Dioxazine Purple to create more shadow on the path.

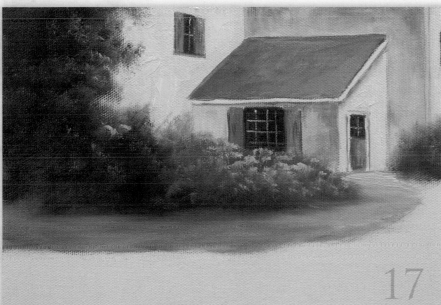

18. BLOCK IN THE GRASS

Block in the grass with the foliage fan brush. Start with a light color at the top—Titanium White + Cadmium Yellow Medium + Brilliant Yellow Light + a small touch of French Ultramarine Blue (just enough to create a green). Add medium to the paint and use short, downward strokes to apply the paint. As you move down the canvas, add more French Ultramarine Blue to the mix to darken the green. Keep the strokes short and vary the colors to add texture to the grass.

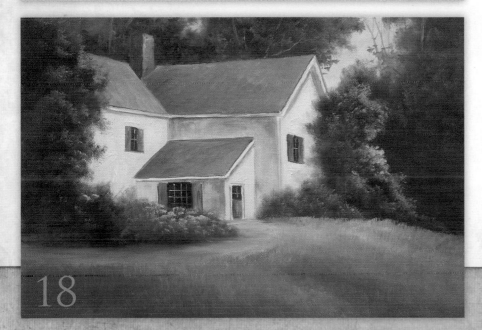

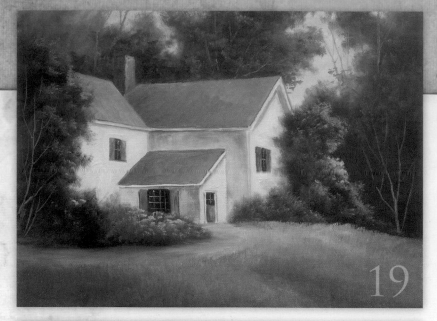

19. PLACE THE TRUNK OF THE FLOWERING TREE

Use the twiggy liner brush to place the trunk and limbs of the flowering tree on the right. The limbs should be thin, and they are painted with Titanium White + Cadmium Orange + French Ultramarine Blue. Thin this mixture with turpentine. Also add the trunk and limbs on the tree to the far left.

20. ADD FLOWERING FOLIAGE

Load the corner of the foliage fan brush with Titanium White and tap blooms onto the tree branches in a zigzag fashion. Make sure the paint is fairly heavy so you're not pushing the paint on the canvas with too much pressure. Use this same technique to add white blooms to the flower bushes in the front and to the bush on the left.

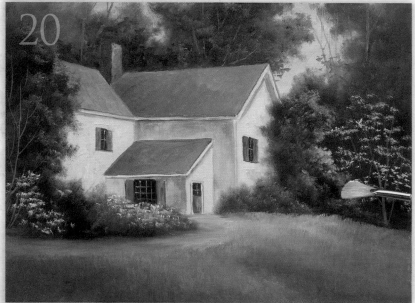

21. PAINT IN THE FLOWERS

To paint the flowers, use the corner of the foliage fan brush. Load the brush by pushing it away from you into the paint. Once the brush is loaded, flip it over so the paint is on the top of the bristles. Carry a lot of paint in the brush so you can tap lightly.

The floral colors are: Quinacridone Red + Titanium White; Cadmium Red Light + Titanium White; Dioxazine Purple + Titanium White and Cadmium Yellow Medium + a touch of Titanium White. Use the pinks and purples for the majority of the blooms, and add just a touch of yellow flowers. Your painting will look too busy if you put on too many colors. Pinks and purples with a touch of yellow make a better composition.

Don't overdo the blooms. Sometimes less is more. Also be sure to preserve some of the dark colors to keep the feeling of depth and shadow.

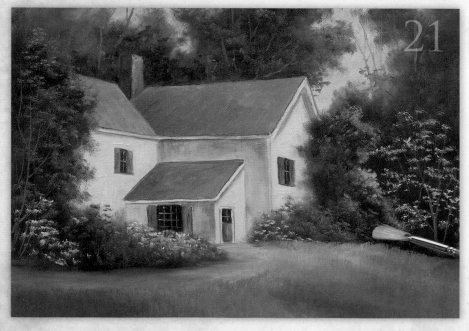

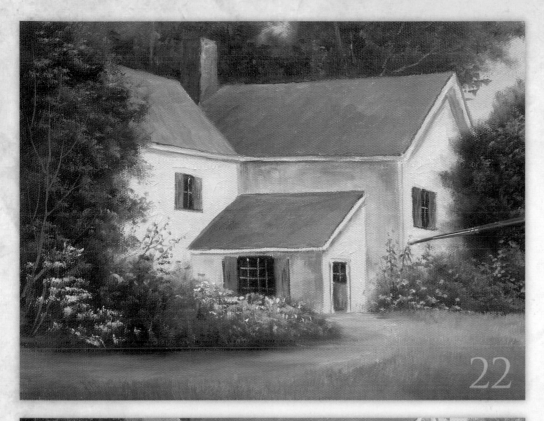

22. DETAIL THE FLOWERS

Tap in the small yellow flowers with the twiggy liner brush. Add the tall flower stalks against the house with the twiggy liner brush and a light green. Dot yellow onto the stalks with the brush.

23. ADD THE FINAL FLOWERS

Add the pink flowers along the bottom with Quinacridone Red + Titanium White. Load this color on the corner of a foliage fan brush. Flip the brush so the paint is on top of the bristles. Place the corner of the bristles against the canvas and make a downward flick of the brush to add these flowers.

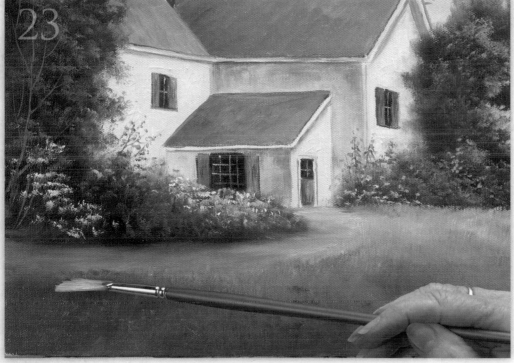

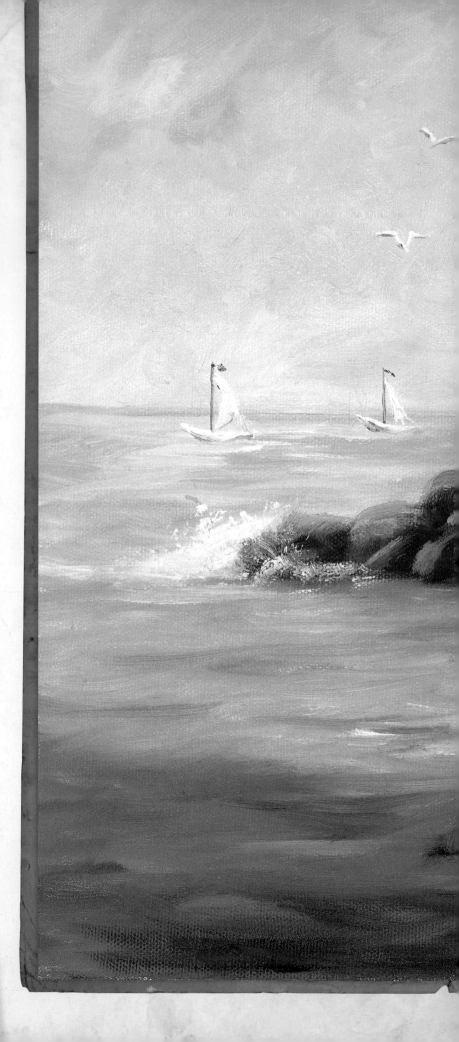

2
COASTAL PARADISE

This is a simple ocean to paint as there are no large waves, yet the motion of the water is there. You will get to practice painting rocks and grass also. The house on the hill is the center of interest. The path serves to lead the eye to the house. I would love to walk down the path to wade in the shallow, warm water. Let's go spend a week there—bring your paints and a couple of good books!

A home by the sea
Would be ever so grand.
Just to stroll down the hill,
And walk in the sand.

Or, wave at the ships
That pass by on their way.
Yes, I think that would be
Such a great place to stay.

D. Dent

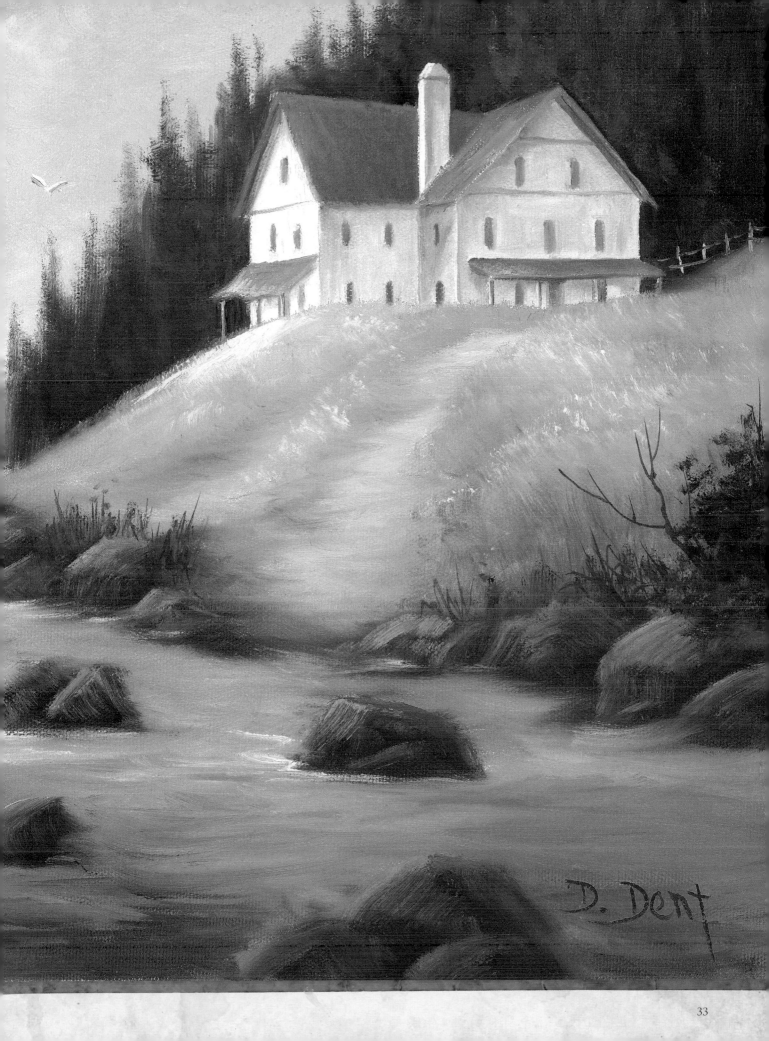

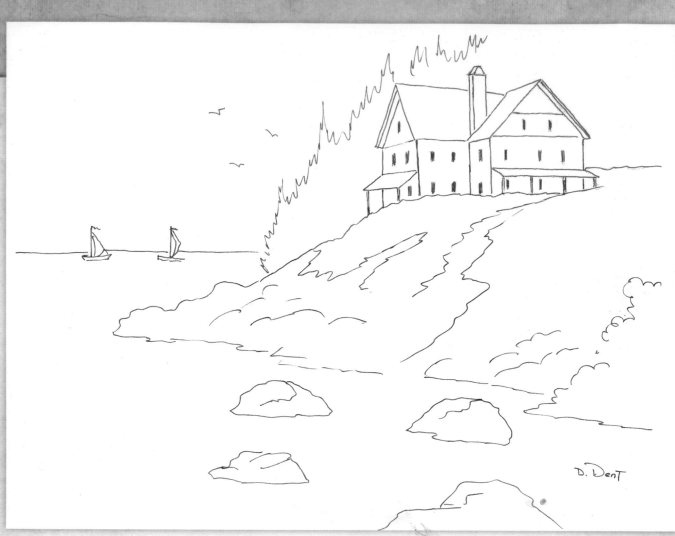

This pattern may be hand-traced or photocopied for personal use only. Enlarge first at 200% and then at 104% to bring it up to full size.

Materials List

Surface
Stretch canvas, 12" × 16" (30cm × 41cm)

Dorothy Dent Brushes
Small background (no. 6 bristle flat)

Small detail flat (no. 4 flat sable)

Foliage fan (no. 4 bristle fan)

Filbert (no. 4 sable filbert)

Twiggy liner (no. 1 sable liner)

Medium
Martin/F. Weber Liquiglaze

Other Materials
Odorless turpentine (for rinsing and cleaning brushes)

Rinse basin

MARTIN/F. WEBER PROFESSIONAL PERMALBA ARTISTS OIL COLORS

 Alizarin Crimson

 Brilliant Yellow Light

 Cadmium Orange

 Cadmium Red Light

 Cadmium Yellow Medium

 French Ultramarine Blue

 Paynes Gray

 Titanium White

 Yellow Ochre

Seeing With the Artist's Eye

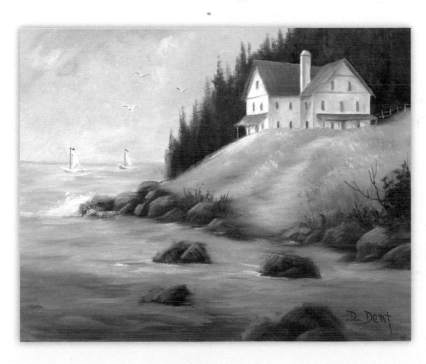

We know at first glance that the house is the center of interest in this painting, and more particularly the left side of the house. The red roof is a great complement to the dark green trees behind it, and the white house stands out brightly from the dark trees as well. Adding more light on the grass under the left side of the house helps to draw attention to that area.

As mentioned in the introduction, the path leads the eye to the house, and even the grass and twigs on the bush in the lower right point toward the house. Be careful not to point objects in a scene out of the picture as this will pull the viewer's eye away from the painting.

This painting could look out of balance with most of the "heavy" elements in the painting on the right side. However, by jutting the rocky point well into the left side, and adding the small sailboats, the painting seems to balance out.

1. PLACE PINK IN THE SKY

Use a small background brush to mix Titanium White + Cadmium Orange + a little Cadmium Red Light and work this color into the upper lefthand side of the canvas. Add a little medium to the mixture to help work the color into the canvas.

2. ADD LAVENDER CLOUDS

Clean the background brush then pick up Titanium White + Paynes Gray + a tiny touch of Alizarin Crimson to make a lavender-gray for the cloud.

Work on the side of the brush and apply the paint with small strokes that scoot to the side of the canvas. Work with an irregular pattern against the pink sky so that the lavender color looks like clouds. The colors should vary a little bit. You can have a touch more pink toward the top and more blue-gray toward the bottom. Paint out the tops of the boats.

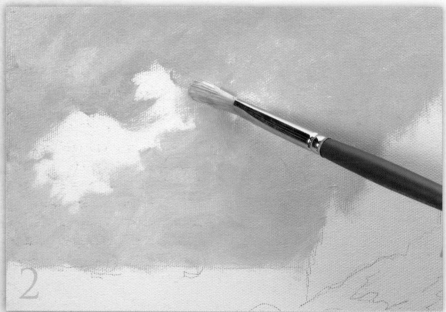

3. HIGHLIGHT THE CLOUDS

To increase the cloudy look, add a bit of Cadmium Orange and Titanium White inside the gray clouds. Also mix some Titanium White + Yellow Ochre to create a medium gold and add this highlight to the edges of clouds. Also use the color to create cloud shapes within the sky. Continue to use the small background brush for this step.

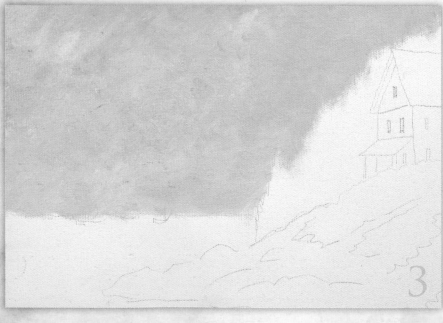

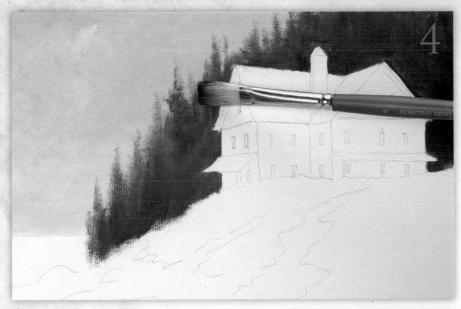

4. PLACE THE BACKGROUND TREES

For the background trees, use the small background brush and mix Paynes Gray + a small touch of Yellow Ochre. This will create a very dark green. Hold the brush sideways as shown in the photo and pat from the bottom of the trees up. Where the trees are thick and running together, pull the brush across a bit. For tops that are less full, simply pat with the side of the brush. This will create the shape of the trees.

Paint carefully around the house using a smaller brush, such as the detail flat. Work some areas a little lighter and some a little darker to suggest value and shape. Pat over some areas with a little more Yellow Ochre to create lighter values.

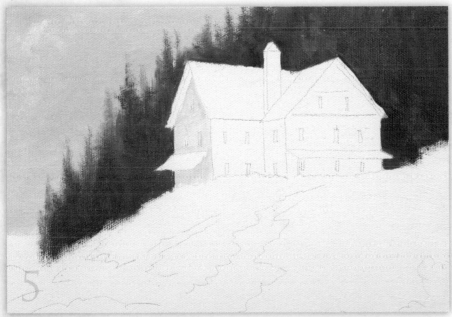

5. BASE THE HOUSE'S LIGHT-COLORED WALL

Switch to the small detail flat brush to paint the house. Base the light-colored wall (front-facing wall) with a light pink color similar to the pink used for the sky (Titanium White + a tiny touch of Cadmium Orange + a tiny touch of Cadmium Red Light). You can go around the windows, but if you get paint on them, you will probably still be able to see your tracing lines.

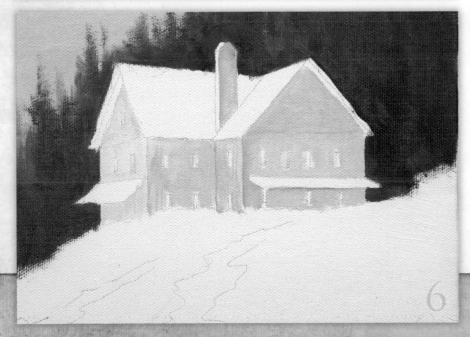

6. BASE THE HOUSE'S SHADOWED WALLS

On the house's shadowed sides, mix a color similar to the lavender-gray color used for the clouds (Titanium White + Paynes Gray + a small touch of Alizarin Crimson) and fill in all the shadow sides of the walls. Paint the right side of the chimney with this color.

Try not to lose the distinction between the walls. You can add a touch more dark in the areas where the walls come together so as not to lose them.

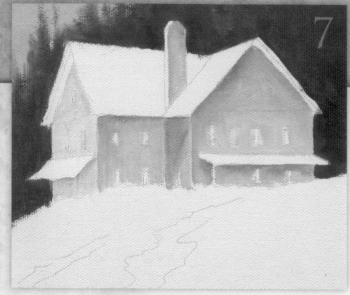

7. ADD SHADING AND CONTRAST TO THE HOUSE

Add under the eaves and under the porch roofs more shading with a very small amount of Paynes Gray. Have just a small amount of Paynes Gray on the brush and blend down into the lavender-gray of the wall. This creates more contrast on the house. Also emphasize the contrast on the different sections of the house so they don't blur together.

8. ADD WINDOWS AND SOME DETAILS

Work more Titanium White on top of the pink on the light side of the house to lighten the value. Work with a thicker paint for this step. Also paint this light color down the light side of the chimney.

Now switch to the filbert brush. Pick up a little Paynes Gray and stroke in the windows. There is no detail on the windows. If the windows look too dark, add a touch of Titanium White to lighten them. If you lost your window tracings, simply eyeball where the windows should go and place them as best you can. They do not need to be perfectly spaced.

Also use this Paynes Gray + a touch of Titanium White under the eaves of the house. Leave just an edge along the overhang for the red of the roof. Also add the horizontal lines on the gable ends and at the cap of the chimney.

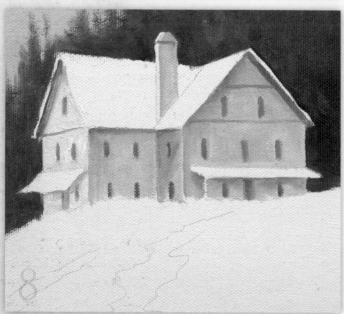

9. PAINT THE ROOF

Switch back to the small detail flat brush to paint the roof. For the dark side (largest side) of the roof, mix Cadmium Orange + a little Cadmium Red Light + a little Titanium White. Thin the paint with a little medium. Once the red is on the roof, brush over the area with French Ultramarine Blue to gray the color a bit. Follow the general slant of the roof. The longer porch roof on the right gable end is the same color as the dark side of the roof.

The light side (the narrow side) of the roof is Cadmium Orange + Titanium White + a touch of Cadmium Red Light. The porch roof on the left gable end is the same color as the light side of the roof.

Put a little edge of the roof color on the far side of the gables to finish the look of the roof.

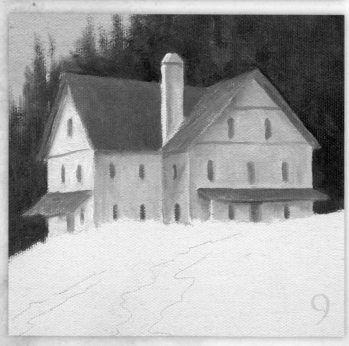

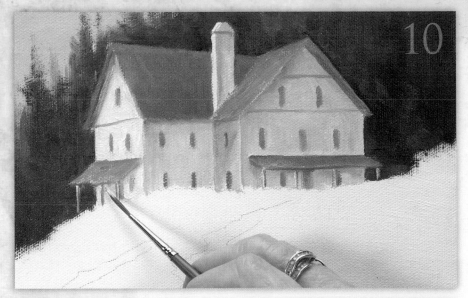

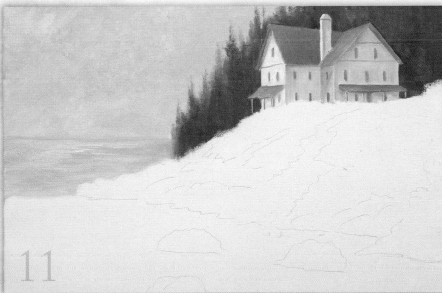

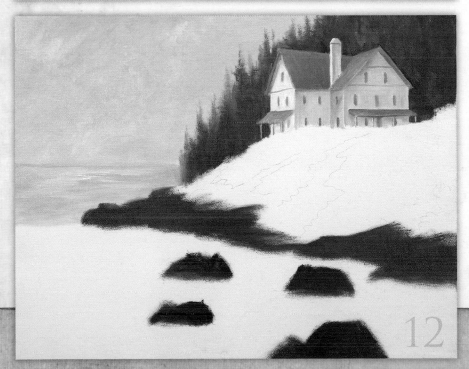

10. ADD THE PORCH POSTS

Use the twiggy liner brush and Titanium White to paint the small porch posts. Add a little Paynes Gray to the right sides of the posts where they are over a light background and don't show up well.

11. PAINT THE DISTANT WATER

Switch to the small background brush for the distant water. Begin with Titanium White + French Ultramarine Blue. Swish this color back and forth on the canvas with horizontal strokes. Don't overblend the color. Paint over the boats and paint this color down to the point where the rocks will stick out. Once the distant water is based in, pick up some additional Titanium White on the side of the brush and streak it back and forth loosely to create some waves in the water.

12. BLOCK IN THE ROCKS

Still using the small background brush, create a dark value of Paynes Gray + a touch of Cadmium Red Light + a touch of Titanium White and block in the rocky shoreline and the rocks in the water. Use very thin paint and scrub it into the canvas. You do not want to use heavy, thick paint because it will be too difficult to highlight over.

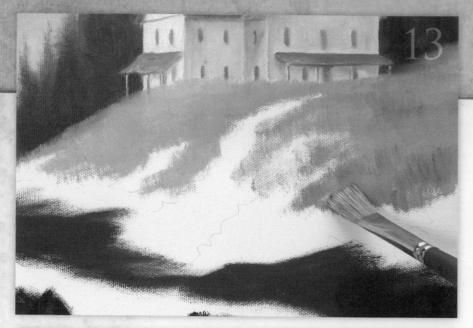

13. PLACE THE GRASS

The grass is painted with the small background brush. Mix Cadmium Yellow Medium + French Ultramarine Blue + Titanium White for a basic grass color. For the lighter grass, add more Cadmium Yellow Medium and Titanium White to the mixture. For the darker grass, add more French Ultramarine Blue or even a little Paynes Gray to the mixture. Skip over the path as you paint.

Start with the lighter-value grass against the house. Use the entire flat of the brush and pat down in strokes. Using a little medium will help you move the color. Add more French Ultramarine Blue to your brush when you go into the shadows. Be sure to vary the color. If you don't add variation, it will look flat. You can add highlights and shadows later, but it's better to work in the varying colors during the basecoat stage.

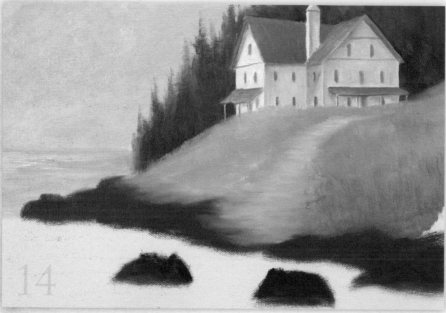

14. PAINT THE PATH

Clean the small background brush and use it to paint the path with Titanium White + Cadmium Orange + a touch of Cadmium Red Light. Move the brush back and forth in horizontal strokes. Do not use vertical strokes. It's fine to pick up a little green from the grass and work it into the path. Also pick up the rock color and work it into the path toward the bottom. Just let the colors work into the path as you catch them on your brush.

15. SHADE THE PATH

Add a bit more shading to the left side of the path by loosely sweeping in a little French Ultramarine Blue. You don't need to be precise with the shadow placement.

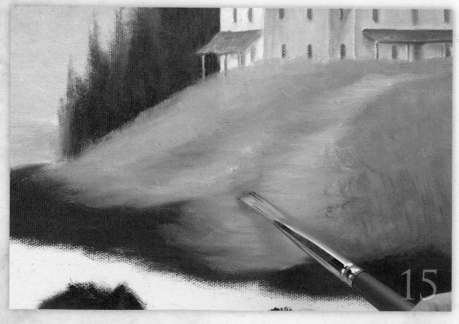

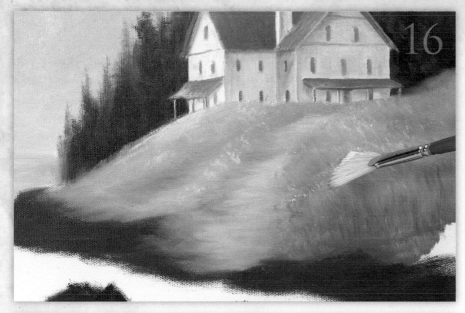

16. HIGHLIGHT THE GRASS

Highlight the grass with the foliage fan brush and Cadmium Yellow Medium + Brilliant Yellow Light + Titanium White. Load only half of the brush by pushing away on your palette. Then flip the brush over so the paint is on top of the bristles (see page 15). Use bouncy strokes that flick downward. Add the highlights here and there to give texture. The highlight should look set in, so soften each stroke as you reach the bottom of it by applying less pressure to the brush.

While you have this color on your palette, load the twiggy liner brush and run a bright streak of this color under the left gable end. Use heavier paint for this small section only.

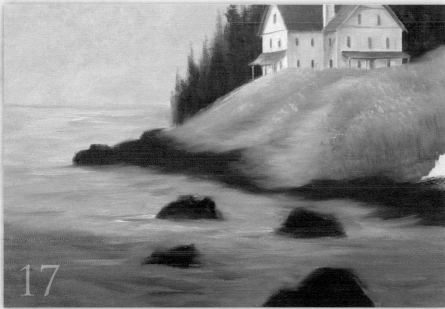

17. PAINT THE MID- AND FOREGROUND WATER

Switch to the small background brush. Mix Titanium White + French Ultramarine Blue to paint the rest of the water. Pick up some Paynes Gray in the foreground water and add some Alizarin Crimson in the middle area of the water. Use choppy, horizontal strokes to push the color on the canvas. The water will get progressively darker as it moves down the canvas. It's fine to pick up some of the rock color in your brush as you work. You can swish in additional lighter values or darker values on top of the basecoat to add more movement to the water.

18. SHAPE THE ROCKS

The rocks are painted with the small background brush. See page 19 for detailed instructions on painting rocks. The tops and light sides are a mixture of Yellow Ochre + Titanium White and Cadmium Orange + more Titanium White to reflect the light pinks and corals of the sky. Be careful not to lose all of the darks on the shadowed sides.

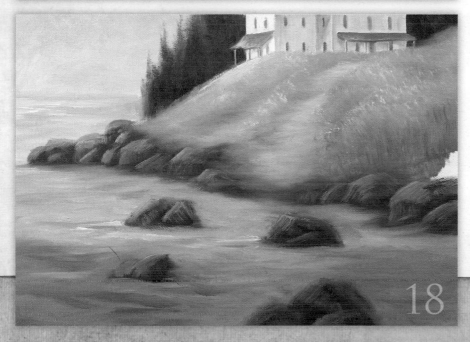

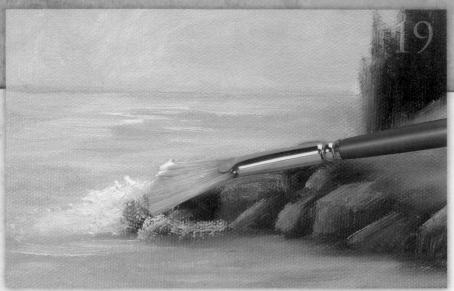

19. ADD SPLASH AND FOAM

Load the corner of a foliage fan brush with Titanium White and tap in the splashes against the rocks, especially at the point where the shore juts out into the water.

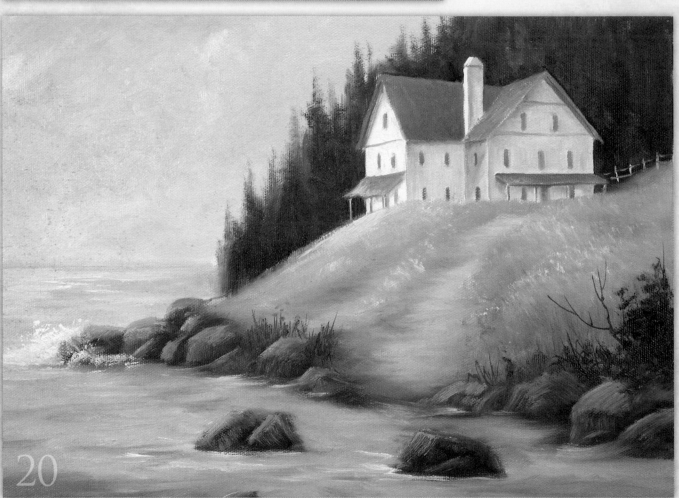

20. PAINT THE BUSH

Add a few more swishes of foam along the coast. Paint the bush on the right edge of the canvas with Paynes Gray and the small background brush. Tap it in with the bottom edge of the brush and make an irregular pattern so it looks like foliage. You can add additional foliage over the backs of the rocks.

Load the twiggy liner brush with thin Paynes Gray and flick up some twigs and branches around the bush. Clean the liner brush and load it with a little Titanium White to add the distant fence behind the house.

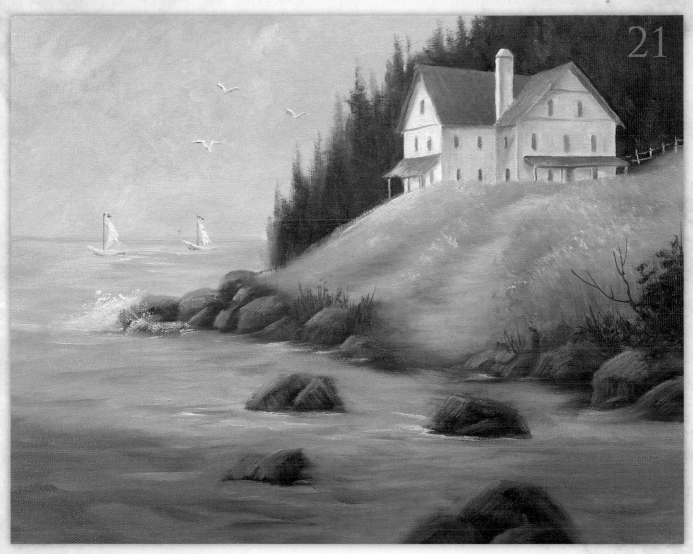

21. ADD THE BOATS AND BIRDS

To paint the boats, pick up a little Paynes Gray on the twiggy liner brush and draw straight vertical lines for the masts. Clean the brush and pick up some Titanium White to paint the sides of the boats. The boats need to look like they are in the water, so they don't need to be perfect. Use thicker paint so the boats are visible against the water. Create the sails with curvy strokes of Titanium White. Add small strokes of a darker shade just beneath the boats to help settle them into the water. Then add small Cadmium Red Light flags to the tops of the boats.

The birds are just flying "v"s of Titanium White with a little Paynes Gray beneath the wings. Place three or so birds wherever you would like them to be.

FALL ON THE JAMES RIVER

The James River is a small river south of Springfield, Missouri, just a few miles from where I live. I took a photo of the fall foliage over the river a few years ago and did this small painting from that shot.

This looks like a rather simple painting, and it truly is not a difficult one, but there is still a lot to learn from it. You will get some practice painting water that is quiet, not rolling like the ocean. You will also get to work on close-up trees with a lot of leaves, and these can be a challenge, but are also fun to do.

Fall comes in so swiftly,
But lingers not so long.
For, before we are ready
The leaves will all be gone.

Let's walk where they are shining
So brightly in the trees,
And turning oh so gently
In the warm October breeze.

D. Dent

This pattern may be hand-traced or photocopied for personal use only. Enlarge first at 200% and at 102% to bring it up to full size.

Materials List

Surface
Stretch canvas, 12" × 16" (30cm × 41cm)

Dorothy Dent Brushes
Small background flat (no. 6 bristle flat)

Detail flat (no. 8 flat sable)

Twiggy liner (no. 1 sable liner)

Martin/F. Weber Museum Emerald

Brushes
No. 6 synthetic filbert, series 6204

Medium
Martin/F. Weber Liquiglaze

Other Materials
Odorless turpentine (for rinsing and cleaning brushes)

Rinse basin

MARTIN/F. WEBER PROFESSIONAL PERMALBA ARTISTS OIL COLORS

 Alizarin Crimson

 Brilliant Yellow Light

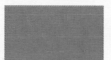 Cadmium Orange

 Cadmium Red Light

 Cadmium Yellow Medium

 Cobalt Turquoise

 French Ultramarine Blue

 Indanthrone Blue

 Titanium White

 Venetian Red

 Viridian

Seeing With the Artist's Eye

This scene has a lot of nice autumn color, which attracts the eyes. I have used more yellows in the lower leaves and on the left side of the tree trunks as highlight. By adding the complement of yellow—lavender—to the dark areas in the vicinity of the yellows, I have created a lot more interest than I would have if I had only painted the tree trunks brown.

If you don't have a color wheel, purchase one to help you remember your color complements, and use them to an advantage in your painting.

Large trees in the foreground call for larger leaves than you would put on more distant trees. I like to paint these leaves with my detail flat, or you might use a sable filbert brush. Be sure to move the brush in different directions, and let the leaves overlap or they will have a spotty look.

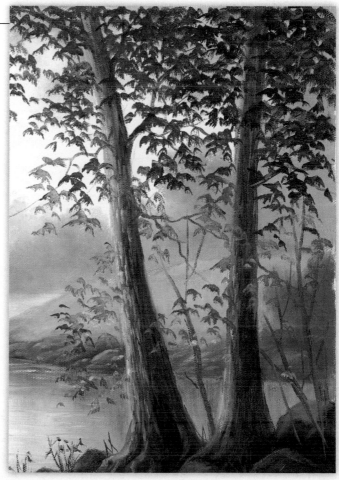

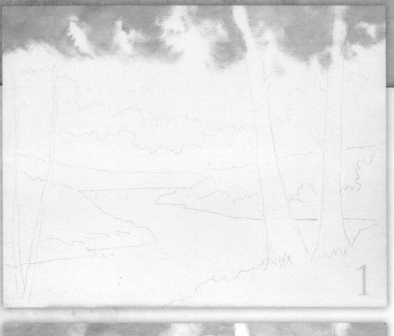

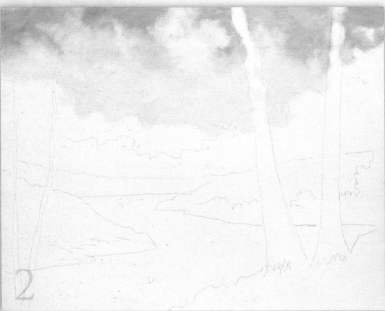

1. PAINT THE LAVENDER SKY

With the small background brush pick up Titanium White + French Ultramarine Blue + Alizarin Crimson to create a lavender color. Paint this color on the topmost part of the sky, leaving irregular patterns and holes for clouds.

2. PAINT THE CLOUDS

Clean the small background brush, mix Titanium White + Brilliant Yellow Light and paint the clouds down to the tree line. Soften this color over the edges of the purple sky. Keep the paint on the bottom of the brush and use bouncy strokes that scoot to the side a bit.

3. ADD MOST DISTANT TREES

Clean the small background brush and for the background trees mix a lot of Titanium White + a touch of French Ultramarine Blue + a very small touch of Cobalt Turquoise. This very light blue color is for the most distant background trees and goes from the first tree line down to the second line.

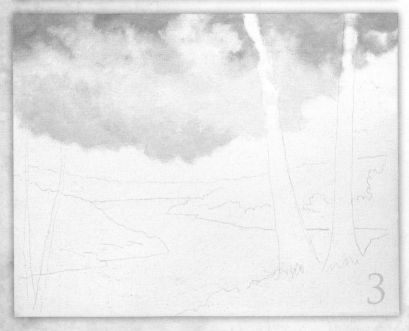

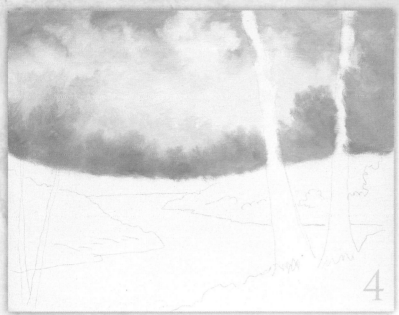

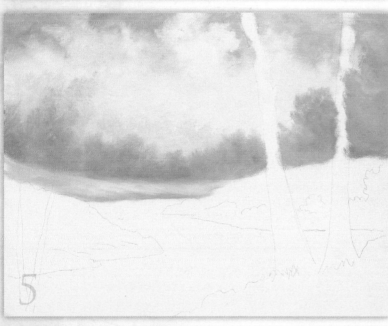

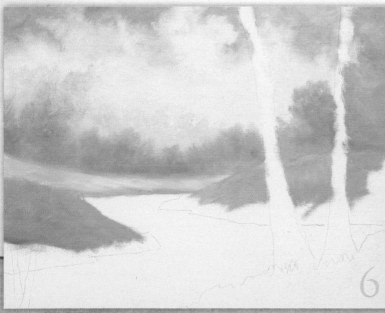

4. ADD THE SECOND LINE OF DISTANT TREES

As you move down into the next area of distant trees mix French Ultramarine Blue + Titanium White + a touch of Viridian + a tiny touch of Alizarin Crimson. It's a darker value of blue with hints of green in it. Allow variations in the color.

5. PAINT THE BACKGROUND GRASS

For the background grass mix Titanium White + Cadmium Yellow Medium + a small touch of French Ultramarine Blue to create a yellow-green. You are still using the small background brush. Brush in the distant bit of ground, and let the paint catch into the wet background trees and pull a bit of the blue color down into the grass. As you move off to the left side pick up a little more blue so the green becomes darker. Directly at the bank, stroke in a small amount of Titanium White + French Ultramarine Blue + a touch of Alizarin Crimson following the slope of the bank.

6. BASE THE MIDDLE-GROUND GRASS

On the middle-ground banks on either side of the water basecoat the grass with French Ultramarine Blue + Titanium White + Cadmium Yellow Medium. This color should be a little darker than the green from Step 5. This color comes down to the bank areas, not all the way down to the water. It's OK to paint out the skinny trees on the left.

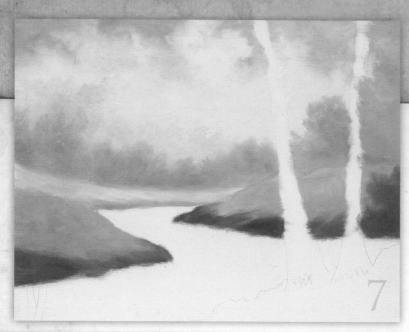

7. BLOCK IN THE BANKS

Use French Ultramarine Blue + Venetian Red + a touch of Titanium White to paint the banks of the river where the dirt would be.

8. ADD THE ROCKS ON THE BANKS

Switch to the detail flat brush to paint the rocks on the banks. Mix Titanium White + a touch of Venetian Red + a touch of Cadmium Orange for the rock color. Like all rocks, you will have a lighter value on top. On the sides of the rocks and between the rocks you will have a little bit of extra dark value that will serve as shadows between the rocks. See page 19 for more instruction on painting rocks.

Some of these strokes will look like rocks, and some are just texture on the bank. Follow the slope of the bank and keep the paint on the top of the brush. Some of the rocks in the foreground can be larger.

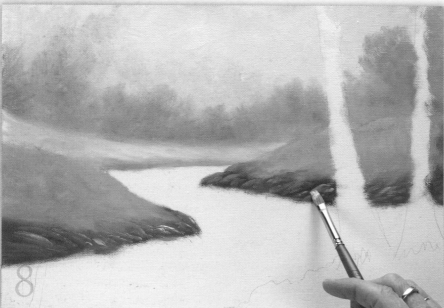

9. BEGIN ADDING THE WATER

Switch to the small background brush to paint the water. You'll begin by painting the most distant water. This area is Titanium White + a touch of Cobalt Turquoise. (You may need to use the detail flat brush to paint the tight area at the very back of the water.) Use short vertical strokes. Take this color around the first bend in the river.

Clean the brush then mix Titanium White + French Ultramarine Blue + a touch of Venetian Red. Lay this color directly beneath the banks and then pull down with the flat of the brush to start the dark reflections of the banks in the water.

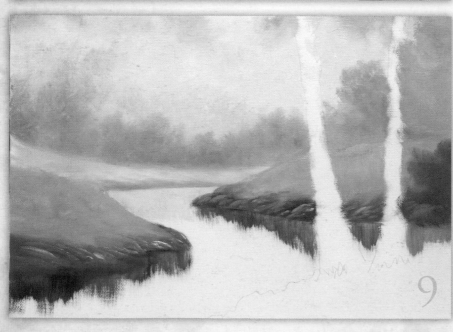

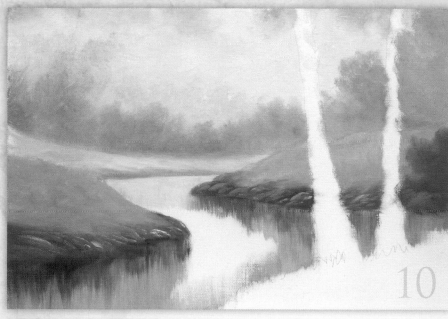

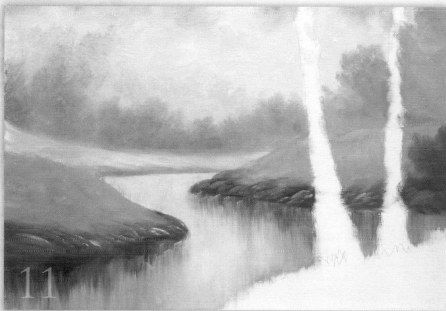

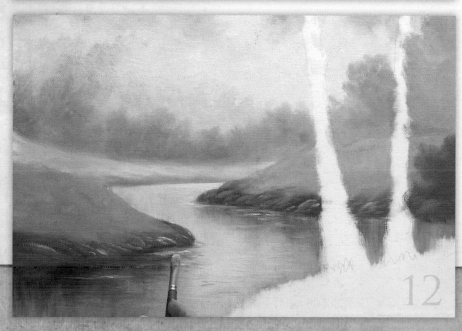

10. ADD MORE COLOR TO THE WATER

Now mix Titanium White + French Ultramarine Blue + Viridian + a small touch of Alizarin Crimson. Use a little bit of medium to help move the paint, but don't make it too wet. Place this color just below the dark you just painted and pull down. Work this lighter color up a bit into the dark color to blend, but don't go all the way up to the banks. Leave the center section of water open for the yellow highlight.

11. PAINT THE BRIGHTEST SECTION OF WATER

Clean the small background brush well. Mix Brilliant Yellow Light + Titanium White and start painting directly in the center of the water area you left unpainted. Then move outward and overlap and blend into the colors on the side. Get rid of all the lines and edges. Use downward, vertical strokes only—no horizontals yet. Don't over blend this area; you still want to see some streaks.

12. DETAIL THE WATER

With the detail flat brush place a line of Titanium White where the water goes around the bend and out of sight. This creates shine. Wipe the brush then sweep it lightly across the water with horizontal strokes to distort the vertical lines you made in Step 11. Sometimes use the chisel edge to create ripples. Pull some of the dark colors into the light areas and vice versa. You can pick up a little extra Titanium White to add some foam patterns along the bank. Keep these in a zigzag pattern, but don't overdo them.

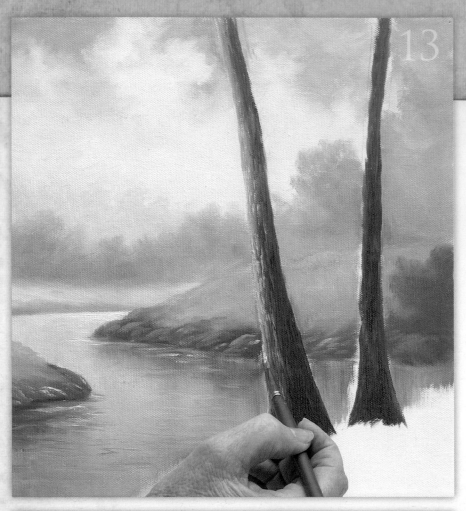

13. PLACE THE LARGE TREES

The large trees are painted with the chisel edge of the detail flat brush. Mix Venetian Red + French Ultramarine Blue + a touch of Viridian to create a dark value. The trunks will be darker to the right and lighter toward the left. You will see some color variation in your mixture and that's fine. Leave a little edge unpainted on the left side. This is where you will place your highlights.

To paint the highlighted edges clean the brush and pick up a little Cadmium Orange + Titanium White. Use the chisel edge of the brush with the paint facing to the left and make choppy, downward strokes that begin at the light edge and move slightly into the dark. You'll also pick up some of the dark color and move it into the highlight. Try adding touches of Brilliant Yellow Light to the left edge of the tree to make it look a little brighter.

In the photo, the tree on the left has been highlighted while the tree on the right has not.

14. ADD MORE TREES

Use the same dark values from Step 13 to paint the trees on the left bank. These narrow trees run right off the canvas. They are highlighted on the left with Brilliant Yellow Light + a touch of Cadmium Orange. Switch to the twiggy liner brush and use the dark-value mix to paint the limbs. Thin the paint to an ink-like consistency with turpentine. The limbs are always larger where they connect to the tree and thin out as they move away from the trunk. Add some twiggy trees on the right bank also.

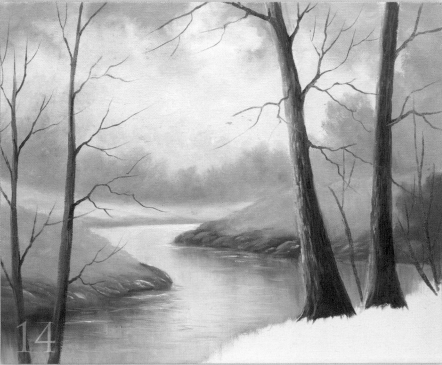

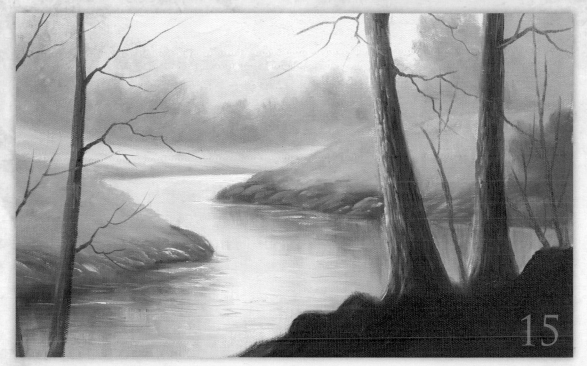

15. PAINT THE FOREGROUND BANK

Block in the foreground bank with the small background brush and French Ultramarine Blue + Venetian Red + Viridian. This area is rocky so block in some bumps at the top to suggest rocks.

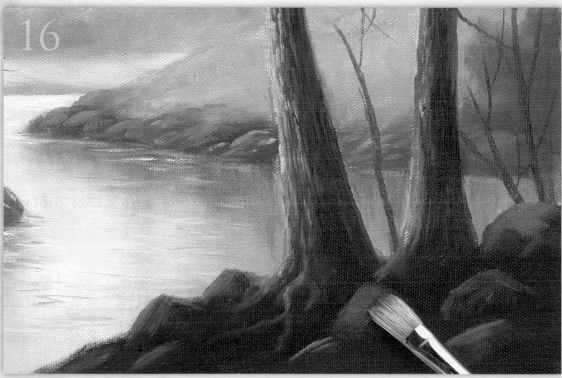

16. PLACE SOME ROCKS

Use the small background brush to create some rock shapes with Titanium White + Cadmium Orange + Venetian Red. Create the top first. Find the light side of the rock. Make two or three strokes to create the top then pull down, but don't make the sides as light as the top. Leave some dark space between the rocks. As you make rocks, you can add a little bit of the roots of the trees wherever they may show. See page 19 for more instruction on painting rocks.

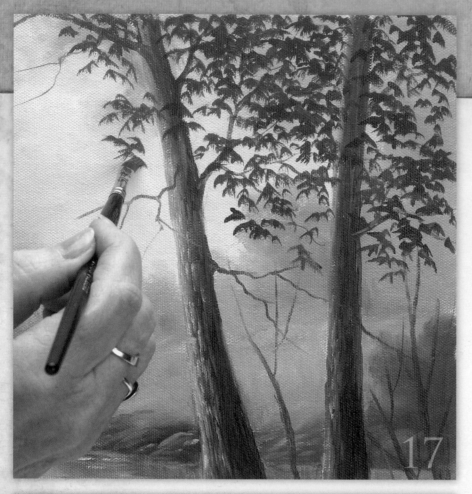

17. ADD THE LEAVES

You don't have to let the background set up, but the leaves will be easier to paint if the background is drier and tackier. You may want to let the painting set overnight before you begin painting the leaves.

The leaves are made with several different color mixes. For the dark leaves use Venetian Red + Indanthrone Blue. For the lighter leaves, pick up some Cadmium Orange + Cadmium Red Light, and for the lightest leaves use Cadmium Yellow Medium.

Load a small synthetic filbert (such as a Martin/F. Weber Museum Emerald no. 6 synthetic filbert) with paint. Lightly place the tip of the brush against the canvas and rock it back and forth to make a squiggly stroke that loosely resembles clusters of leaves. Use a bit of medium to help move the paint on the canvas. See page 17 for detailed instructions on this technique.

Let the leaves overlap and blur them together a bit. Place the leaves wherever you want them. Don't just stick them directly on the limbs. Work over the limbs and put some in the sky, but remember to leave some holes for the sky to show through.

18. ADD MORE LEAVES

As you move toward the left begin to add Cadmium Yellow Medium and Cadmium Orange to the leaf colors to reflect sunlight.

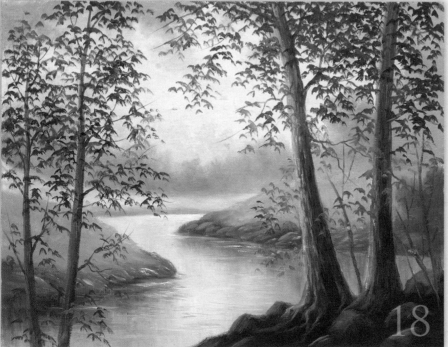

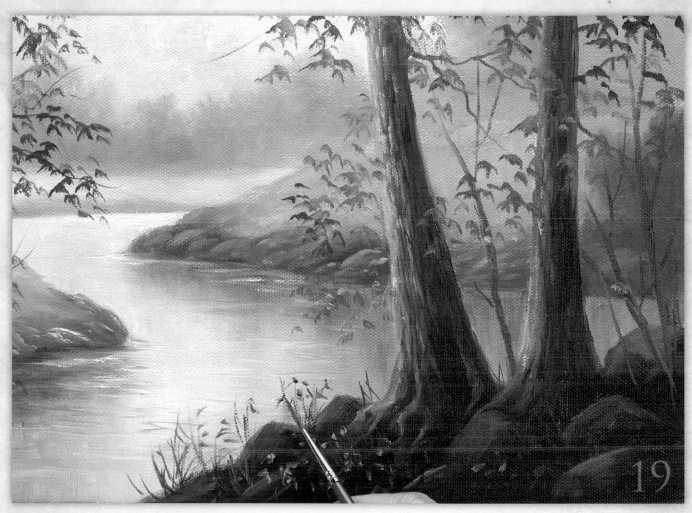

19. DETAIL THE FOREGROUND

Add highlights to the rocks with more Cadmium Orange or other light values if you need more contrast. Using the twiggy liner brush, add twigs and weeds around the rocks with a thinned mix of Indanthrone Blue + Venetian Red. Flick these weeds up into the rocky area along the right foreground bank. You can add more grass with thinned Cadmium Orange that will show up nicely against the dark of the rocks. Then use the end of the liner or the corner of the detail flat to add dabs of color that suggest fallen leaves. Use touches of Cadmium Orange and touches of Cadmium Yellow Medium for these leaves.

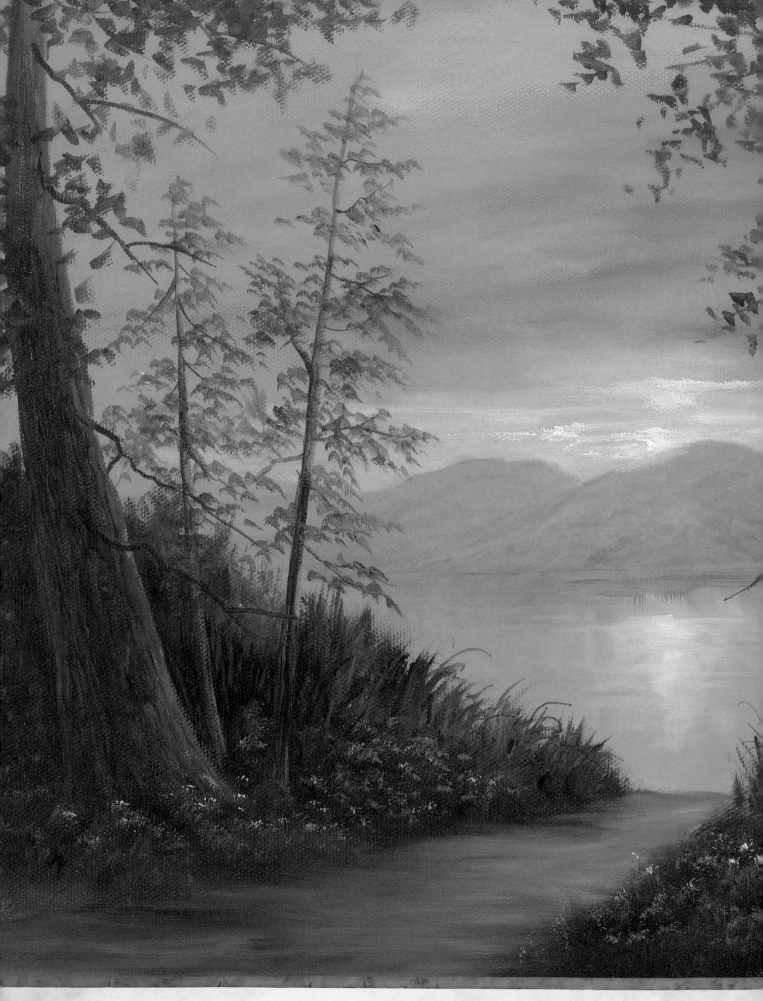

NAKNEK LAKE

This colorful painting is basecoated with acrylic paint, DecoArt Americana Peaches 'n Cream. The peach-orange acrylic base helps the painting look vibrant, just like the setting sun looks many times over Naknek Lake in Alaska. My husband, D. A., spent twelve years in Alaska and loves to talk about his experiences there. We also have good friends, Martin and Mollie Flack, who spent many years there and are now moving back. Mollie gave me the photo that I used for this painting.

This painting will enable you to practice on many standard landscape elements such as water, grass and trees.

Come, let's walk in the sunset
By the lake shoreline.
The breezes are gentle,
The evening is fine.

The glow is so fleeting,
It will soon fade away
As night steals the beauty
From the end of the day.

D. Dent

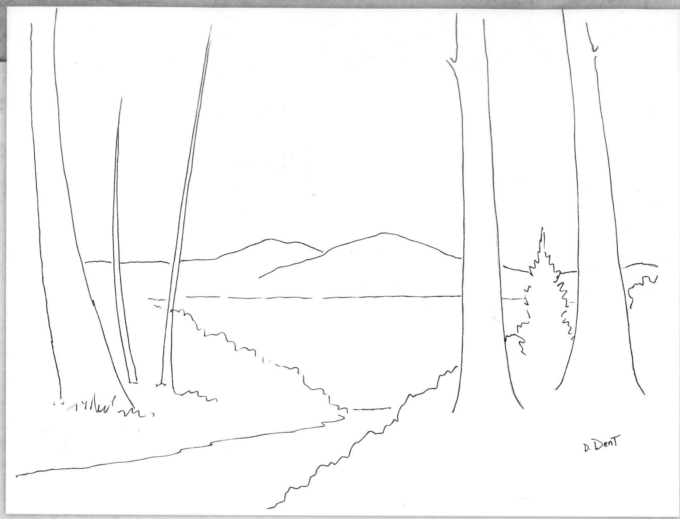

This pattern may be hand-traced or photocopied for personal use only. Enlarge first at 200% and then at 104% to bring it up to full size.

Materials List

Surface
 Stretch canvas, 12" × 16" (30cm × 41cm)

Dorothy Dent Brushes
 Small background (no. 6 bristle flat)
 Detail flat (no. 8 flat sable)
 Foliage fan (no. 4 bristle fan)
 Twiggy liner (no. 1 sable liner)

Martin/F. Weber Museum Emerald Brushes
 No. 6 synthetic filbert, series 6204

Medium
 Martin/F. Weber Liquiglaze

Other Materials
 DecoArt Americana Acrylic Paint, Peaches 'n Cream
 Odorless turpentine (for rinsing and cleaning brushes)
 Rinse basin
 Paper towel

MARTIN/F. WEBER PROFESSIONAL PERMALBA ARTISTS OIL COLORS

Burnt Sienna

Cadmium Orange

Cadmium Yellow
Medium

French Ultramarine
Blue

Raw Umber

Titanium White

Ultramarine Violet

Seeing With the Artist's Eye

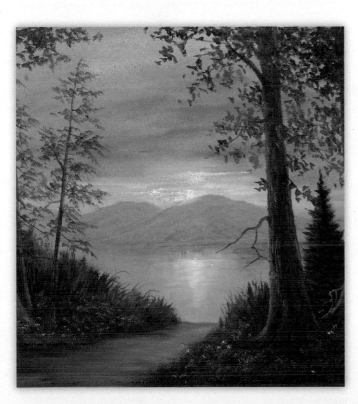

I chose very strong contrasts between light and dark in this painting, with the sunset over the mountains as the focal point. This painting has a cheerful feel because of the bright, warm colors.

I like the play of light on the inside edges of the large trees and the little bit of cool lavender on the outside edges. By softening the edges of the trunks a bit in this way, and getting rid of the hard, dark line, the trees take on a rounder shape rather than looking flat, cut out and stuck on.

Since there was a basecoat on the canvas in a peach-orange color, I used the wipe-out technique for the highlights on the distant mountains. Wiping out color to expose the bottom layer of color can be used where you want the base color to be highlight.

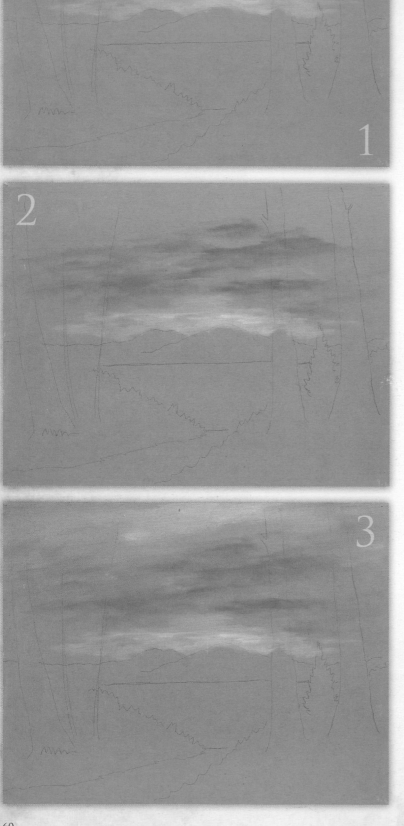

Basecoat the entire canvas with DecoArt Americana Peaches 'n Cream acrylic paint. Let the canvas dry completely before you begin painting with oils.

1. PLACE A SUN GLOW BEHIND THE MOUNTAINS

Use the small background brush and mix Cadmium Yellow Medium + Titanium White. Spread this color over the tops of the mountain peaks using horizontal strokes.

2. ADD ORANGE TO THE SKY

Add a touch of Cadmium Orange to the Cadmium Yellow Medium + Titanium White mixture and place this color above the yellow on the canvas. Leave some of the peach basecoat color showing through. Don't put the orange color on heavily. Work in an uneven pattern so the sky does not look striped.

3. ADD BLUE TO THE SKY

Mix Titanium White + a touch of French Ultramarine Blue to create a soft blue. Begin by placing this color at the top of the canvas and then work down into the orange, still leaving some spots open so the basecoat color shows through. Use a little medium to help move the paint on the canvas.

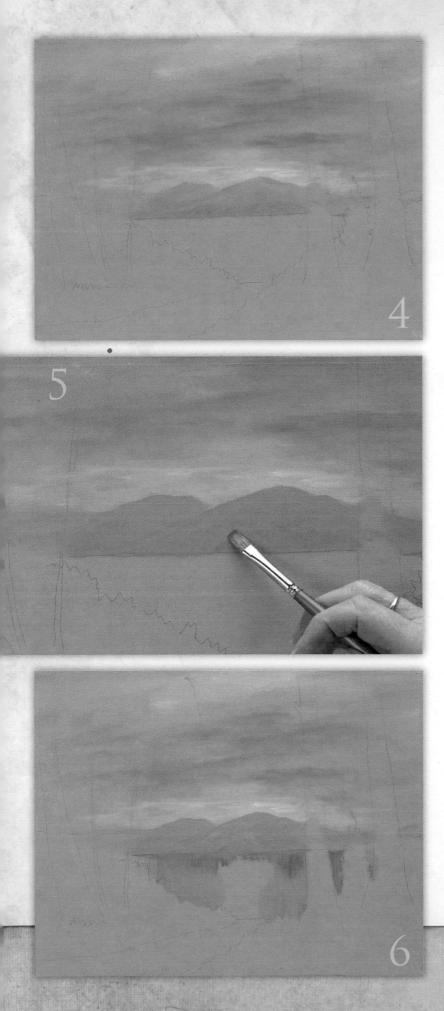

4. BLOCK IN THE MOUNTAINS

Use the small background brush for the mountains. Mix Titanium White + Ultramarine Violet + a touch of French Ultramarine Blue. Use very thin, stretched-out paint on the mountains. It should not be a heavy coat of paint. If the color picks up some of the yellow from the sky, it will create a green look on the mountains, which is fine.

5. WIPE OUT HIGHLIGHTS

Switch to the detail flat brush and put some turpentine on it, then wipe the turpentine off the brush. Use the brush to wipe out some of the paint on the mountain to expose the base color underneath. You don't want to wipe the paint off completely; leave a bit of blue to show some texture. Occasionally dab the brush on a paper towel to remove the paint you are picking up. Wipe off the color until you are pleased with the look. There's no specific place to stop, but you want to quit before you wipe out too much. Leave the dark value at the base of the mountain to suggest distant trees.

6. BEGIN PAINTING THE WATER

Switch to the small background brush. Mix French Ultramarine Blue + a very small touch of Cadmium Yellow Medium + Titanium White. Scrub this color on the water directly under the mountain and then pull down vertically.

Pick up more French Ultramarine Blue and pull the blue down under the greenish color on the sides. Use a little medium to stretch the paint very thin. Leave the middle of the water open as this is where the water will be brightest.

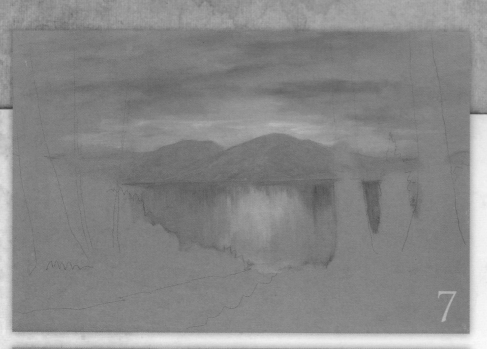

7. ADD YELLOW TO THE WATER

Mix Cadmium Yellow Medium + Titanium White and place this color in the center of the water using vertical strokes. Overlap the other colors a bit as you come to them. Clean the brush and then continue to stroke the color down. This blends the colors but allows the basecoat to show through.

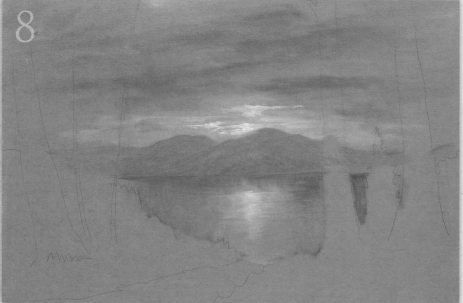

8. BLEND THE WATER AND ADD BRIGHT HIGHLIGHTS

With the clean small background brush, lightly sweep back and forth over the water in horizontal strokes to blend the vertical lines. Some of the paint may lift a bit and expose the base color, which will translate as ripple lines and look nice.

Pick up very thick Titanium White and place it in the sky right beside the mountain and then add a few bright highlights in the lower part of the sky. Then place a reflection of this bright spot directly below it in the water. Lay it in with a downward stroke, and then pull across it to distort it and blend it a bit.

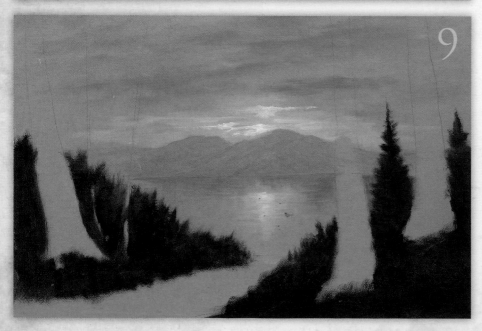

9. BLOCK IN THE DARK FOREGROUND

Create a dark value with Raw Umber + French Ultramarine Blue and block in the area behind the trees with the small background brush. This is a dark, weedy area so you want an uneven edge here. Suggest the silhouette of two pine trees in the distance. Also use this same dark value to block in the foreground under the trees.

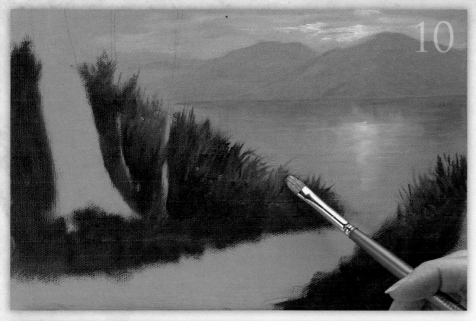

10. HIGHLIGHT THE FOREGROUND

Switch to the detail flat brush. Pick up a little Cadmium Yellow Medium + Cadmium Orange + a touch of Titanium White from time to time and highlight the edges of the weedy area. This will create a green color, but you still want the dark to show. Keep the edges loose and wispy so they look like tall weeds.

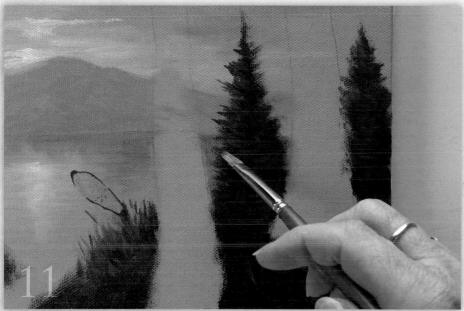

11. HIGHLIGHT THE PINE TREES

Pat little hints of green with the mix from Step 10 on the pine trees to create a bit of dimension, but retain the dark silhouette look.

12. PLACE THE THIN TREE TRUNKS

Place the trunks of the narrow trees on the left with Raw Umber and the detail flat brush. Use the twiggy liner to pull out some limbs with thin Raw Umber. You don't need to add a lot of limbs as you can add more later if necessary.

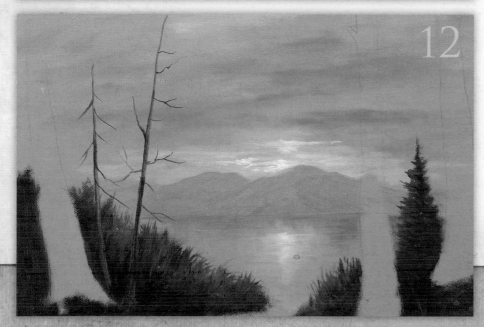

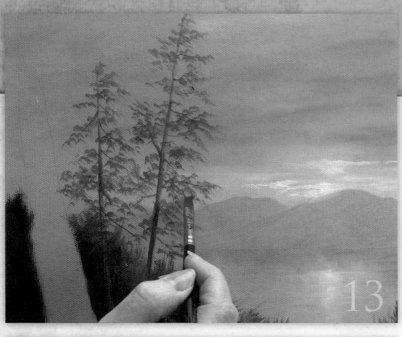

13. ADD THE LEAVES

For the leaves on the narrow trees, mix French Ultramarine Blue + Raw Umber and thin it with medium. Don't use a lot of paint; instead, use more medium than paint so the leaves look soft. Use the tip of the no. 6 synthetic filbert brush to place delicate leaves on the branches. Let the tip dance against the canvas and don't push hard. Let the strokes smudge together in some places.

14. BASE THE LARGE TREE TRUNKS

Use the detail flat brush and a mix of Raw Umber + French Ultramarine Blue + a touch of Burnt Sienna to paint the trunks of the large trees. Use the chisel edge of the brush and short, choppy, downward strokes to create bark-like texture as you go. Add a little medium to move the paint around. The trees facing the sun over the mountains will be lighter so leave the inside edges unpainted.

15. ADD LIMBS AND HIGH-LIGHTS TO THE TRUNKS

Switch to the twiggy liner and add limbs to the trees with Raw Umber + French Ultramarine Blue so the color matches the trunks. Use medium to thin the paint. You don't need to paint many of the limbs because you will have a lot of leaves covering them. Add a Cadmium Orange highlight to the limbs that go over a dark background so the limbs show.

Switch to the detail flat brush and use the chisel edge to chop in highlights on the trunks with Cadmium Orange + Titanium White. Keep the paint on one flat side of the bristles and hold the brush so the paint is facing the light source, which is the sun spot.

16. ADD COOL HIGH-LIGHTS TO THE TREES

Mix Ultramarine Violet + Titanium White and add cool highlights to the shadowed sides of the trees. Still use the chisel edge of the detail flat and this time hold the brush so the paint faces toward the edge of the canvas. Start this highlight on the outside edge of the tree, not right in it, so you are actually placing the highlight next to the tree and chopping into it.

17. PAINT THE PATH

Switch back to the small background brush, mix Cadmium Orange + Titanium White and scrub this color on the path using horizontal strokes that are parallel with the bottom of the canvas. Let the brush catch into the wet colors on the sides of the path so the dark values are brushed into the path as well. As you move down the path, pick up some Ultramarine Violet + Titanium White in the dirty brush and continue to stroke the color on the path. As you move closer to the bottom of the canvas, you may want to pick up some Raw Umber in your brush to keep the path dark, but not too purple.

18. ADD GRASS TO THE FOREGROUND

Switch to the foliage fan brush. Mix Cadmium Yellow Medium + French Ultramarine Blue. Load the paint so it will be on the top corner of the brush and use short, downward strokes to add green to the dark foreground areas. See page 15 for detailed instructions on loading the foliage fan brush. Keep your strokes light and don't lose all of the dark.

19. PAINT THE FLOWERS

Place the flowers using the corner of the foliage fan brush, with the paint on the top of the bristles. Just tap the corner of the brush on the canvas and give it a quick downward flick. The flowers are Ultramarine Violet + Titanium White, Cadmium Orange + Titanium White and some are pure Titanium White. Put them on in a random and loose manner so they don't look stiff and formally placed.

20. ADD LEAVES TO THE LARGE TREES

Switch to the detail flat brush. Mix Raw Umber + French Ultramarine Blue. Thin the paint slightly with medium. Tap the color around the limbs of the large trees to create leaves. Place leaves in the sky and all around the trees. Don't just stick them on the branches. Hold the brush so you can roll it against your middle finger and flip the brush back and forth so the leaves lay in different directions. See page 17 for detailed instruction on this technique. You can add touches of Cadmium Yellow Medium to the leaf colors, but don't make them too light.

Use the twiggy liner and an orange mix (such as the mixture from Step 2) to add some root details to the base of the tree if you wish.

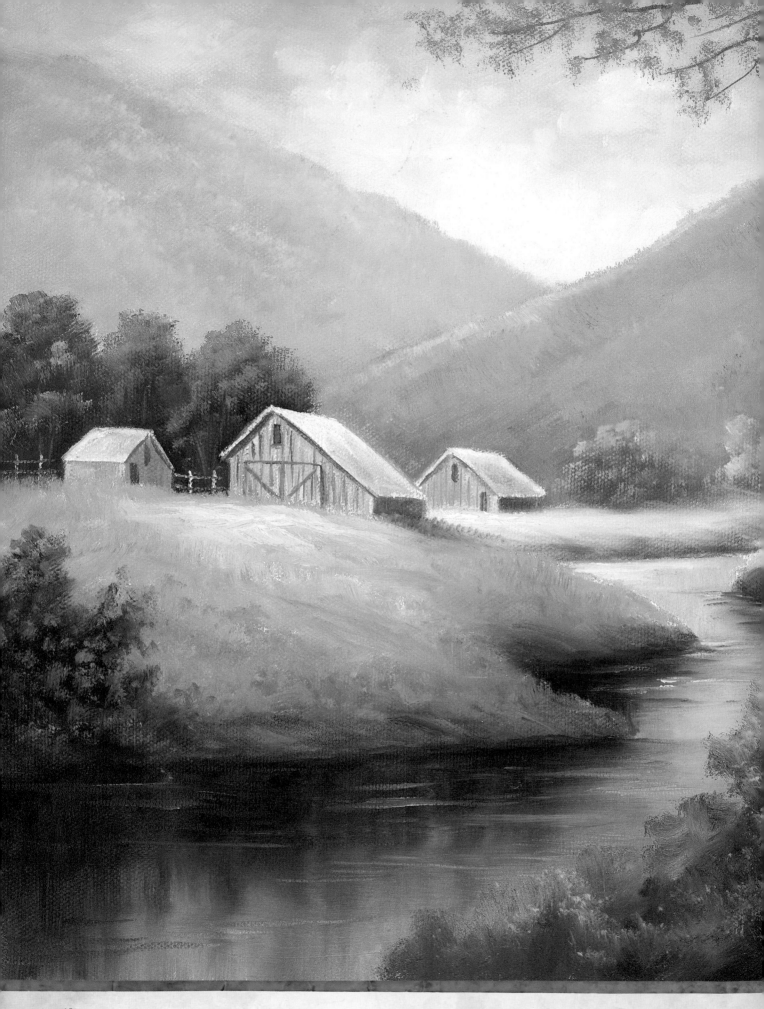

WEST VIRGINIA SPRING TIME

This peaceful country scene could be found in many different states. I like the combination of greens and blues highlighted with the brighter yellow-green for the sunny look.

Because I grew up on a farm in Missouri, I enjoy painting this type of country scene. As a child I spent many happy hours with my friends playing in our barns and outbuildings. Barns such as these are fast disappearing from the American landscape and being replaced with metal buildings that have no personality.

Let's go to the country in Springtime,
To smell the fresh-cut hay.
We'll travel down small gravel roadways
On a bright, sunny day in May.

Our basket is right beside us.
Here's a beautiful, quiet little stream.
Let's stop here for our picnic
We'll eat, and rest, and dream.

D. Dent

This pattern may be hand-traced or photocopied for personal use only. Enlarge first at 200% and then at 104% to bring it up to full size.

Materials List

Surface
Stretch canvas, 12" × 16" (30cm × 41cm)

Dorothy Dent Brushes
Small background (no. 6 bristle flat)

Small detail flat (no. 4 sable flat)

Foliage fan (no. 4 bristle fan)

Twiggy liner (no. 1 sable liner)

Medium
Martin/F. Weber Liquiglaze

Other Materials
Odorless turpentine (for rinsing and cleaning brushes)

Rinse basin

MARTIN/F. WEBER PROFESSIONAL PERMALBA ARTISTS OIL COLORS

Alizarin Crimson

Brilliant Yellow Light

Cadmium Orange

Cadmium Red Light

Cadmium Yellow Medium

French Ultramarine Blue

Paynes Gray

Raw Umber

Titanium White

Seeing With the Artist's Eye

Always be aware of the direction of the light as you paint. The extra sunlight in front of the barn pulls your eye to the barn and helps establish the buildings as the center of interest. Often, students don't put enough strong sunlight in their paintings to make them come to life. The addition of the extra touches of sunlight on the grass as well as in the foliage in the foreground makes the painting much more interesting than it would be without those brighter areas.

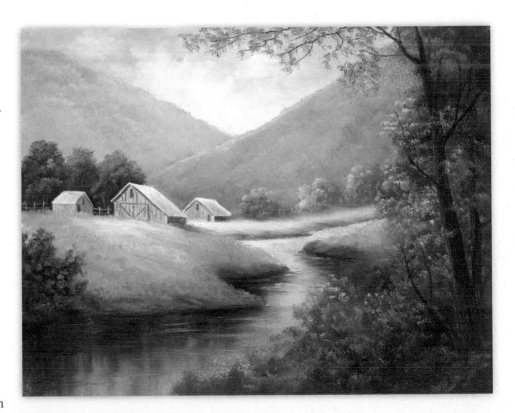

Darker values in the bush to the left, in the foreground water, and in the foreground foliage contrast nicely with the lighter values in the distance and give the painting depth. Work to control the values in your paintings so objects look like they belong in the areas where you have painted them, giving your painting the proper perspective.

1. PAINT THE SKY
Use the small background brush to establish the sky. Mix Titanium White + a touch of French Ultramarine Blue + a tiny touch of Alizarin Crimson to create a very soft lavender (use lots of Titanium White in the mix). Pick up even more Titanium White as you move down into the valley.

2. ADD THE CLOUDS
Clean the brush and add a bit of Brilliant Yellow Light + Titanium White to the sky to create a cloudy look. Work on the corner of the brush with the paint on top of the bristles (see page 15). Keep most of the clouds concentrated in the valley area.

3. BASE THE MOUNTAINS
Base in the mountain on the left with Titanium White + French Ultramarine Blue + a touch of Paynes Gray + a touch of Alizarin Crimson. This lavender color should still be fairly light because it is in the distance, but it needs to be darker than the sky so the two areas don't blend together.

Then base the mountain on the right with the same colors but make it a little darker than the mountain on the left. Work carefully around the buildings.

If you find the mountain on the left is too dark compared to the mountain on the right, go back and add some Titanium White to the left-side mountain.

4. HIGHLIGHT THE MOUNTAINS

Switch to the foliage fan brush to highlight the mountains. Follow the slope of the mountains as you apply the highlight using short, downward strokes. Highlight the left-side mountain with Brilliant Yellow Light + a small touch of French Ultramarine Blue so it still resembles yellow but looks a little green. Don't cover all of the purple underneath the highlight.

On the right-side mountain, increase the green in the highlight color by mixing Brilliant Yellow Light + Cadmium Orange + a touch of French Ultramarine Blue. You still don't want to lose all of the purple, so leave some showing through.

Make sure there is contrast where the two mountains come together. The one in front should be brighter.

You can also pick up more of the mountain's basecoat color to darken it if you've lost too much of the purple.

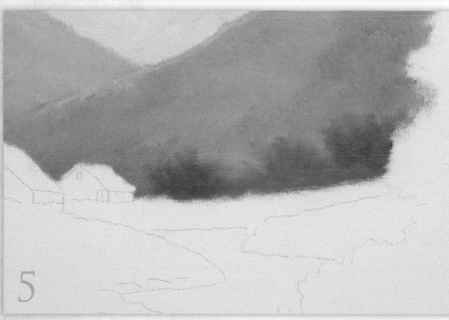

5. BLOCK IN THE TREE LINE

Use the small background brush to base in the distant trees. The tree line is Paynes Gray + Alizarin Crimson + Titanium White. Be sure this mixture is darker than the mountain's basecoat. Use bouncy strokes that sweep to the side and keep the paint on the top of the bristles. Switch to the small detail flat brush when painting around the buildings.

6. HIGHLIGHT TREE LINE

Highlight the tree line with the small background brush. Mix Brilliant Yellow Light + Cadmium Yellow Medium + Titanium White + a touch of French Ultramarine Blue. Keep the paint on the corner of the brush. Try to make the trees lighter on their left sides because the light is coming from the left.

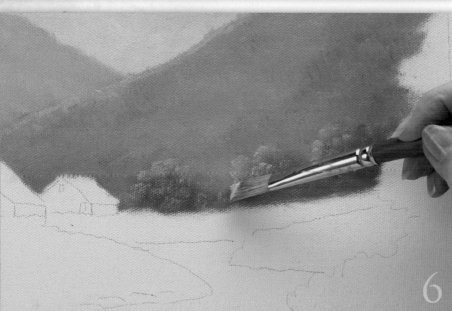

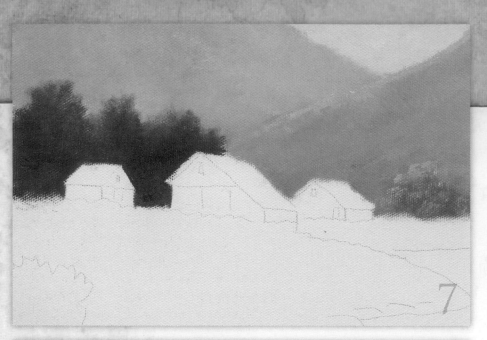

7. PLACE THE DARKER DISTANT TREES

The trees to the left of and behind the building are quite a bit darker than those on the right. Paint these trees with the small detail flat brush. Mix Paynes Gray + a touch of Cadmium Yellow Medium + a touch of Alizarin Crimson for the base color. You want to create a black-green color.

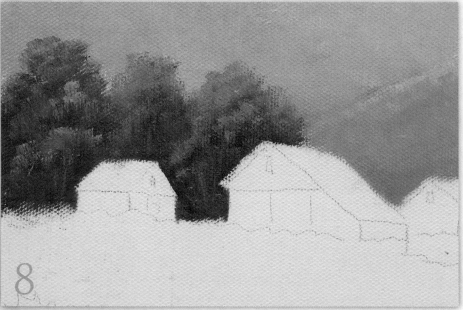

8. ADD HIGHLIGHTS TO THE TREES

Highlight these darker trees with the small detail flat brush and a mixture of Cadmium Yellow Medium + a touch of French Ultramarine Blue + Titanium White. This mixture should be a little darker than the highlights on the trees to the right. Keep the paint on the top of the brush and tap in the highlights. Add suggestions of trunks with the clean, damp chisel edge of the detail flat brush. It will lift the paint enough to look like trunk lines as you slide it through the trees here and there.

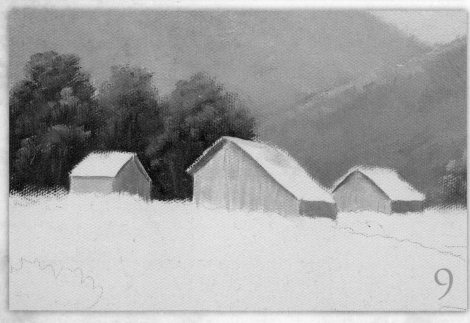

9. BLOCK IN THE BUILDINGS

Mix Titanium White + a touch of Paynes Gray + a touch of Alizarin Crimson to create a purplish gray. This is a very light value. Paint the fronts of the barns with the small detail flat brush. The left side of each building is a little darker so add more Paynes Gray to the mix. Paint a line of this dark value under the roof edge on the light side for shadow.

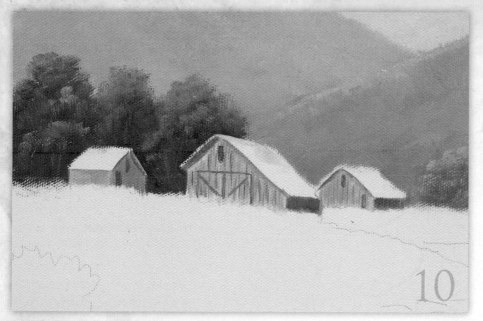

10. DETAIL THE BARNS

Highlight the left sides of the barns with Titanium White + a touch of Cadmium Orange + a touch of Cadmium Red Light (a soft peach color). Work with the chisel edge of the small detail flat brush. Be sure to let some of the purple show through; don't cover it all up. You can stroke in a little bit of Raw Umber to create small crack lines resembling siding board. Switch to the twiggy liner brush to add the windows and the lines around the door with Raw Umber.

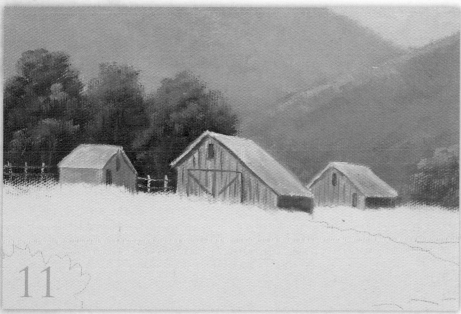

11. PAINT THE ROOFS

The roofs are Paynes Gray + Titanium White at the bottom and straight Titanium White at the top where the sun is hitting them.

Use the twiggy liner brush and Titanium White to paint the little fence between the left and middle buildings.

12. PLACE DISTANT BANK

Switch to the small background brush to paint the distant bank behind the water. Mix Paynes Gray + a touch of Titanium White + a touch of Raw Umber and create a little bank following the slope of the ground.

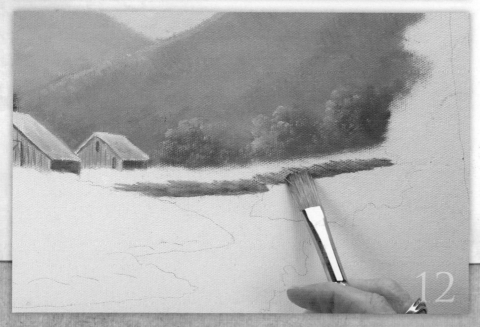

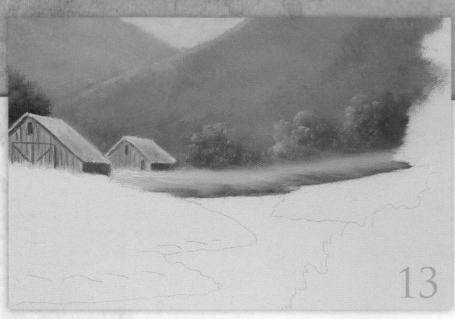

13. ADD THE DISTANT GRASS

Mix Titanium White + Cadmium Yellow Medium + a touch of French Ultramarine Blue to create a very light green and paint this color in the field behind the dark bank. Soften this color into the top edge of the bank, but don't lose all of the dark color. Also blend some of this green color up into the tree line so there is no hard line between the field and tree line.

Pick up a little Brilliant Yellow Light and place it between the center barn and the right-side barn for extra highlight.

14. BLOCK IN THE REMAINING BANKS

Mix Raw Umber + a touch of Paynes Gray + a touch of Alizarin Crimson and stroke this dark color along all sections of the banks.

15. TAP IN THE GRASS

Switch to the foliage fan brush to paint the grassy banks. Mix French Ultramarine Blue + Cadmium Yellow Medium + Titanium White to create a green. Use medium to help move the color on the canvas. Paint with about one-half of the brush and use short, downward strokes. Avoid painting with the center of the brush as you will get arches. Allow for variation in the grass, picking up more yellow at the top of the hill and more blue at the bottom.

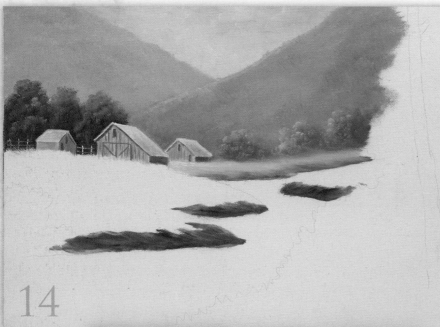

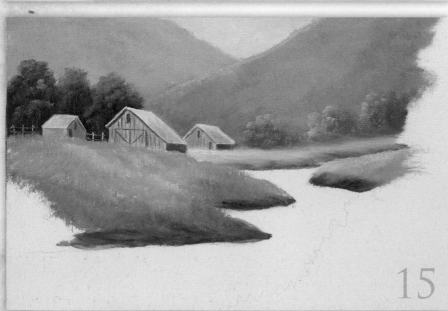

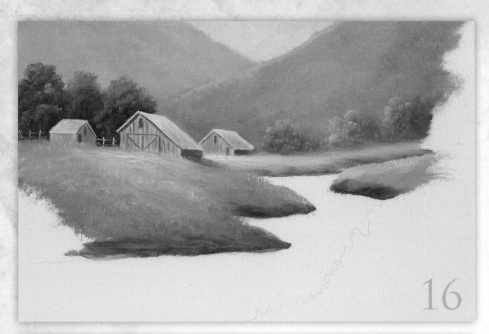

16

16. DETAIL THE GRASS

Switch to the small background brush and pick up a little Paynes Gray. Pat this color next to the largest barn to create a shadow on its right side. Clean the brush, then pick up Brilliant Yellow Light and pat this color in front of the barn to create a highlight in the grass.

Mix Titanium White + a touch of Alizarin Crimson + a touch of Cadmium Orange and brush some bare spots in the grass where the dirt shows through. Don't let this mix be too red. The green below this color will dull it a bit.

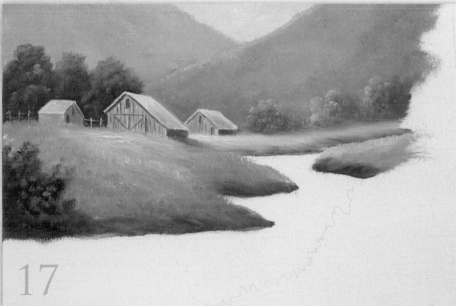

17

17. ADD LEFT-SIDE BUSH

Paint the bush in the left corner with Paynes Gray + Raw Umber + a touch of Alizarin Crimson. Tap in the bush using the corner of your small background brush. Make the shape irregular and uneven; you don't want to create a round ball. Pick up one of the midtone greens on your palette and tap it onto the bush to give it a bit of dimension.

If the bank area looks too flat, add a few strokes of green or the orange-white mix from Step 16 to make it look like it has some rock texture.

18. CREATE SHADOWS IN THE WATER

Use the small background brush to add a shadow in the water under the closer banks. Mix Paynes Gray + a touch of Alizarin Crimson. Place this color directly beneath the bank and pull straight down. Use a little medium to help move the paint.

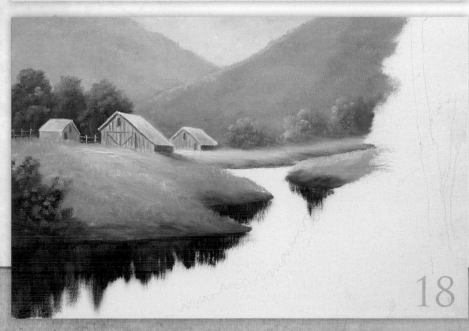

18

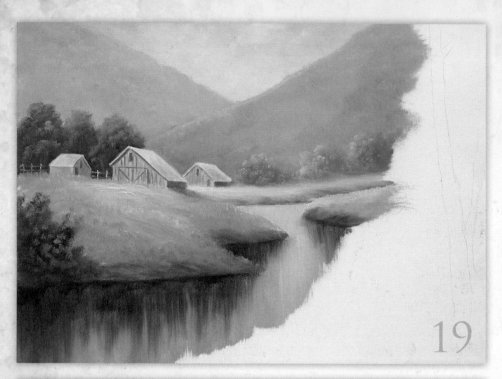

19. ADD THE WATER

Mix French Ultramarine Blue + Titanium White + a small touch of Alizarin Crimson to create a light-value blue. Use the small background brush to place this color at the very back of the water then move down the river. Start below the dark areas of water and brush the light blue color up into the dark. Don't over blend. You want to see a streaky look in the water.

Clean your brush and pick up Titanium White + Brilliant Yellow Light and stroke this in the center of the water, overlapping the blue on the sides to create a shine.

20. BLEND THE WATER

Switch to a clean, dry foliage fan brush and sweep the brush back and forth very gently across the water to distort it a bit. Use a light touch and don't scrub. Hold the brush so the bristles are parallel to the bottom of the canvas and sweep back and forth. Then turn the brush so the bristles are perpendicular to the bottom of the canvas and sweep back and forth. You only want to distort the downward lines, not wipe them out entirely.

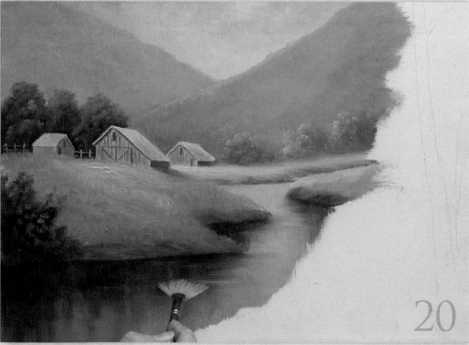

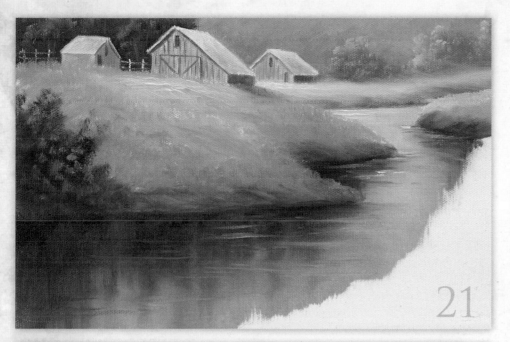

21. DETAIL THE WATER

Switch to the small detail flat brush and pick up a little Titanium White + Brilliant Yellow Light. This should be thicker, heavier paint. Put some extra shine in the very back of the water and then here and there through the river to show movement. Use little zigzag strokes with the paint on the bottom of the brush. You'll pick up some dark color as you apply the shine and that's fine. Soften the edge of the banks in a few places if it looks too sharp.

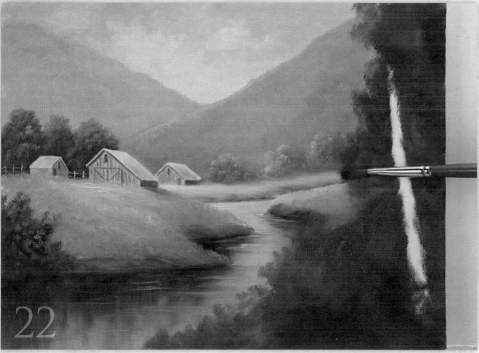

22. BLOCK IN THE FORE-GROUND FOLIAGE

Switch to the small background brush. Mix French Ultramarine Blue + Paynes Gray + a touch of Raw Umber and begin basing in the lower right corner. This bottom area is very dark. You can also add a little Alizarin Crimson to this mixture. Working on the bottom corner of the brush, use short, bouncy strokes that scoot slightly to the side. Avoid long, sweeping strokes. Think of this as bushy foliage, so the rougher and more textured you can make it, the better.

As you move toward the center of the painting pick up more French Ultramarine Blue and some Cadmium Yellow Medium to create a green. Try to save some of the tree, but if you paint it out, that's fine.

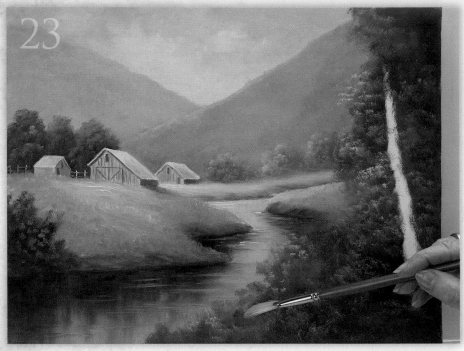

23. HIGHLIGHT THE FORE-GROUND FOLIAGE

Highlight the foliage with the foliage fan brush. Load the corner of the brush with Cadmium Yellow Medium + Brilliant Yellow Light + a touch of French Ultramarine Blue and tap in some lighter foliage over the area you just blocked in. Also tap in some orange color (Titanium White + a touch of Cadmium Orange + a touch of Alizarin Crimson). Work on the corner of the brush.

24. ADD THE FORE-GROUND TREE

Switch to the small detail flat brush to paint the foreground tree. Mix Paynes Gray + a touch of Alizarin Crimson + a touch of Raw Umber and paint the trunk. There will be an orange highlight on the left edge of the tree so leave the edge unpainted.

Clean the small detail flat brush and mix Titanium White + Cadmium Orange. Place the highlight just to the outside of the trunk and chop in with short, downward strokes to blend the colors.

Add the limbs with the twiggy liner brush using the dark mixture from the tree trunk. Remember to vary the placement of the limbs and let them overlap.

For composition's sake, it is important that the limb that comes down from the top of the canvas goes a little beyond the center of the canvas. Don't let it stop in the middle. This branch ties the two sides of the canvas together.

Once the trunk is placed you may want to tap some foliage over the bottom of it to make it look settled into the background.

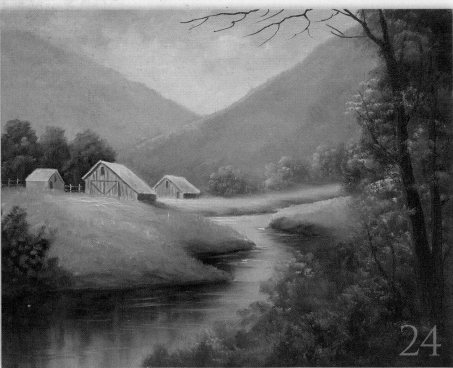

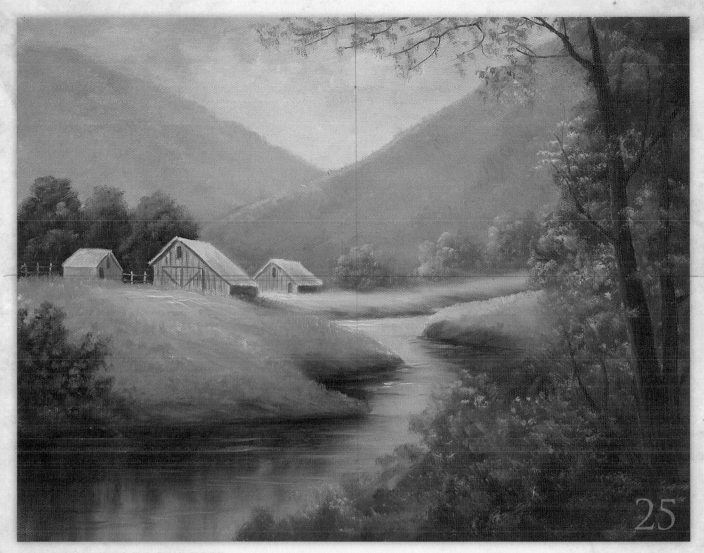

25. ADD LEAVES TO THE TREE

Tap the leaves on the tree with the small background brush. Mix Cadmium Yellow Medium + Paynes Gray to create the green for the foliage. Keep the leaves light and airy. Focus mostly on the branches that come from the top of the canvas.

STARRY NIGHT

Beginning with a dark acrylic basecoat (such as DecoArt Americana Deep Midnight Blue) on a canvas is helpful when you're painting a night scene. It sets the tone of the painting and helps to keep you from painting too much light in the sky and ground.

Snow scenes do not necessarily need to look cold. They can be warmed up by adding light values with warmer colors such as yellows, reds and oranges. This scene *does* look cold to me, but the touch of warmth from the windows invites you inside where you know it is cozy, and perhaps there is a kettle of hot soup waiting on the stove for supper.

I'd love a little cabin
Tucked down into the snow,
With chairs set for two
By the fire's golden glow.

We'd have a good, hot supper
Then walk out into the night
To marvel at the beauty
Of the distant stars so bright.

D. Dent

This pattern may be hand-traced or photocopied for personal use only. Enlarge first at 200% and then at 104% to bring it up to full size.

Materials List

Surface
Stretch canvas, 12" × 16" (30cm × 41cm)

Dorothy Dent Brushes
Small background (no. 6 bristle flat)

Detail flat (no. 8 sable flat)

Foliage fan (no. 4 bristle fan)

Twiggy liner (no. 1 sable liner)

Medium
Martin/F. Weber Liquiglaze

Other Materials
DecoArt Americana Acrylic Paint, Deep Midnight Blue

Odorless turpentine (for rinsing and cleaning brushes)

Rinse basin

White graphite paper

MARTIN/F. WEBER PROFESSIONAL PERMALBA ARTISTS OIL COLORS

 Cadmium Orange

 Cadmium Red Light

 Cadmium Yellow Medium

 Indanthrone Blue

Paynes Gray

 Raw Umber

 Titanium White

 Ultramarine Violet

 Viridian

Seeing With the Artist's Eye

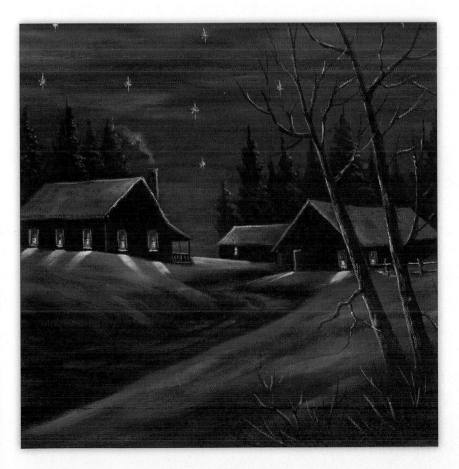

Night scenes with lights in the windows are always appealing. Make sure you put the light in the windows with thicker paint so the windows really shine. Without these warm lights, the painting would not be very interesting. The addition of some lavender and blue in the snow works well against the yellow and orange in the windows. Orange is the complement of blue and yellow is the complement of lavender, so the windows will glow nicely.

Something was needed in the foreground to balance the painting. I chose trees and some little sticks and weeds in this scene. A piece of an old fence, or more bushes could have been added instead.

The stars are a little too large to look real, but as they add so much interest to the painting, I let them be that big. You don't need many, however, or it will look too busy.

Basecoat the entire canvas with DecoArt Americana Deep Midnight Blue acrylic paint. Let the canvas dry completely. Transfer the pattern with white graphite paper.

1. STREAK IN SKY COLOR

Use the small background brush to paint the sky. Mix Indanthrone Blue + a touch of Titanium White + a touch of Paynes Gray and streak this color back and forth across the sky. Occasionally add a touch of Ultramarine Violet. You can lose some of the treetops, but try to preserve as many as you can. Don't cover all of the canvas. Let some of the dark background color show as part of the sky. Be sure to paint under the porch roof and in the small areas between the two buildings. Use the detail flat brush for these areas.

2. PLACE THE BACKGROUND PINES

Switch to the detail flat brush to paint the background trees. Create a very dark mix of Indanthrone Blue + Raw Umber + Paynes Gray. Start each tree by patting a vertical line in the center of the tree, then fill out the shape like a Christmas tree. See page 18 for detailed instructions on this technique.

3. HIGHLIGHT THE TREES

Tap just a tiny bit of Titanium White + a speck of Viridian on the right sides of some of the trees. Keep the paint on the top of the detail flat brush. You don't want a lot of highlight on the trees, just a little bit to create shape.

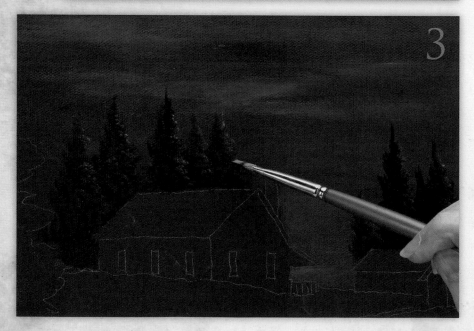

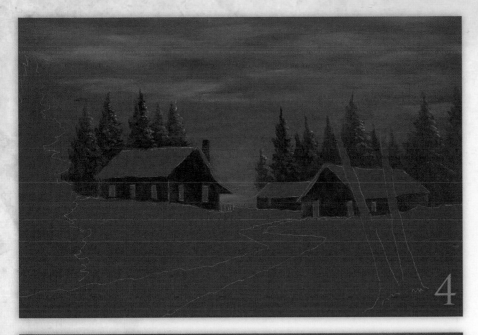

4. BASECOAT THE BUILDINGS

Base the walls of the buildings with Paynes Gray + Raw Umber using the detail flat brush. Work around the windows. Once the buildings are blocked in, add a bit of Titanium White and Indanthrone Blue to the dark base mix and highlight the corners and edges of the buildings. Run a little line down the wall and pull in a bit to lighten the area and create contrast. Put just a little bit of light along the gable end of the building on the left.

Base the chimney using the same technique and colors.

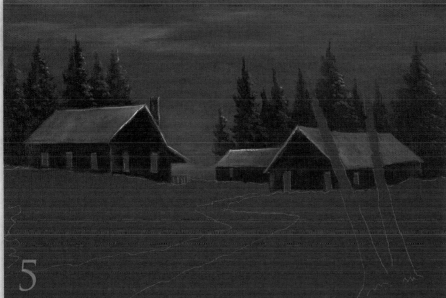

5. PAINT THE ROOFS

Paint the roofs with Indanthrone Blue + Titanium White + a touch of Paynes Gray. Even though there is snow on the roof, it is not really white. The roof is a midtone blue, the same general color as the sky. Add a touch more Titanium White toward the tops and peaks of the roofs.

Remember this is a night scene, so you don't want to make the snow too bright. You can even let a little bit of the dark base color show through in some places.

Put an edge of lighter blue along the edge of the gable with the twiggy liner brush. The right edge of the chimney has a narrow line of Titanium White + a small touch of Cadmium Orange + a small touch of Cadmium Yellow Medium.

After the roofs are painted, you can stroke some lavender tones on them with Ultramarine Violet.

6. ADD THE PORCH AND WINDOWS

Paint the porch with the twiggy liner brush and Paynes Gray.

Clean the brush then mix a little Cadmium Yellow Medium + Cadmium Orange and block in the windows.

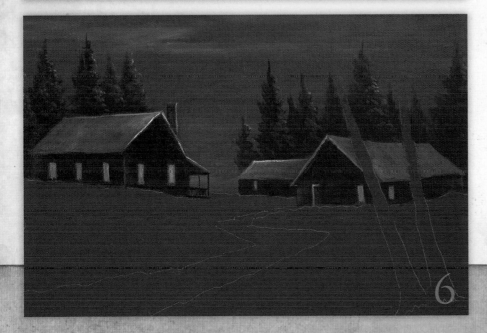

7. HIGHLIGHT THE PORCH AND DARKEN THE WINDOWS

Highlight the porch with a little of the window color placed on top of the banisters and to the left side of the posts. Don't thin the paint, just dip the tip of the twiggy liner brush in the light mix.

Still using the twiggy liner, pick up some Raw Umber + a small touch of Cadmium Red Light and add some of this mix to the top of the windows to darken them. It can look almost as if there are curtains in the tops of the windows. Darken only the tops of the windows.

8. DETAIL THE WINDOWS

Put a small, thick dot of Cadmium Yellow Medium in the bottom of each window with the twiggy liner brush. Place the windowsills directly under each window with Titanium White + a touch of Cadmium Yellow Medium. To suggest a frame, sketch some slightly thinned Titanium White + Indanthrone Blue down the sides of each window. Divide each window into two panes by placing a horizontal line of Paynes Gray + Raw Umber across the center.

9. BLOCK IN THE DARK-VALUE SNOW

Switch to the small background brush to paint the snow. Mix Paynes Gray + Indanthrone Blue for the dark value and brush this color on the snowbanks following the slope down toward the road. Also brush some dark values under the large tree on the right. Place some dark color in the road as well. Use medium to stretch the paint and help it move.

10. ADD LIGHT SNOW TO THE GROUND

Mix Titanium White + Paynes Gray + touches of Ultramarine Violet and begin to brush in the snow. Don't make the snow too light. Remember, this is a night scene. You want to come down to the banks and go over them a little with the light color, but don't lose all of the dark value. Apply the paint thinly and use the base color of the canvas for shading. Follow the contour of the snow as you work over the banks. You can paint right across the large foreground trees if they are in the way.

Leave the snow somewhat streaky so it looks like drifts.

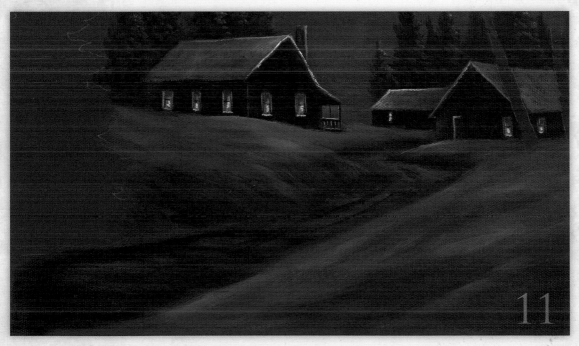

11. ADD SNOW TO THE ROAD

Now swish a little light snow in the road using straight, horizontal strokes that are parallel to the bottom of the canvas.

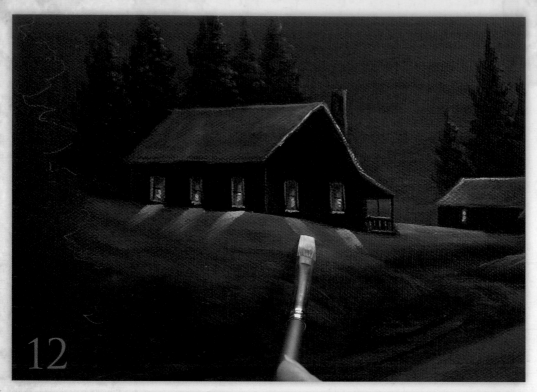

12. PLACE THE REFLECTED LIGHT

Switch to the detail flat brush to place the reflected light from the windows on the snow. Mix Titanium White + Cadmium Yellow Medium + Cadmium Orange for the reflected light. Set the brush down under the window and give it a quick flick. Don't scrub in the color or you will lose the highlight. Also place some of this reflected color around the porch to show light coming from there.

13. BLOCK IN THE LARGE PINE TREE

Switch to the foliage fan brush for the large pine tree. Mix Indanthrone Blue + Paynes Gray + Raw Umber and add a bit of medium to the paint. Create a center line for the large pine tree on the left. Then use the corner of the foliage fan brush holding the handle at about two o'clock and pat to create a wedge stroke (see page 18).

14. ADD SNOW TO THE TREE

Clean the foliage fan brush and pick up a little Titanium White + Indanthrone Blue. Tap a little snow on the tree branches, especially on the right side of the tree. You don't want much of the light color on the tree nor should you take the snow all the way across it. Let the snow stagger into the center and then fade out. Keep the paint on the top of the brush as you work.

15. PAINT THE BARE TREES AND THE WEEDS

Switch to the detail flat brush for the bare trees on the right. Mix Paynes Gray + Indanthrone Blue + Raw Umber for their trunks and limbs. Apply the paint on the trunks with the chisel edge of the brush. Use the same colors for the limbs but use the twiggy liner brush and thin your paint to an ink-like consistency. Stagger the branches. Don't place one directly across from another. Move either up or down. You don't need to create a lot of limbs, just enough to make it look like a nice, balanced tree.

Add some dark weeds and grasses around the bottom of the trees.

16. ADD HIGHLIGHTS TO THE TREES

With a clean twiggy liner brush, highlight the left sides of the bare trees and the tops of most of the limbs with Titanium White. Start the highlight just to the left of the tree then come into the tree with a few downward strokes. It's important to start outside the trunk line. Let the highlight line skip down, and don't make it too rigid. It can be hit-and-miss. Also highlight the tall weeds around the trees.

17. PAINT THE STARS AND CHIMNEY SMOKE

Paint the stars in the sky with the twiggy liner brush and Titanium White. The stars start as crosses. Then put "x"s in the middle of the crosses to complete the stars. Place as many stars as you want, but make sure you have a good balance.

Switch to the detail flat brush and paint the smoke coming from the chimney with circular strokes of Titanium White.

18

18. PAINT THE DISTANT FENCE

Use the twiggy liner brush to place fence posts next to the building on the right. Mix Raw Umber + Paynes Gray for the fence color. Once the posts are placed, add the railings. Then highlight them with Titanium White. Toward the window add a touch of Cadmium Orange to the highlight to show the light reflected from the window.

OLD STONE MILL

7

Old water mills are among my favorite painting subjects. They are picturesque reminders of times gone by.

This painting has more detail than some in this series, so if you like to detail you will enjoy painting this. Remember, you are free to change my line drawing to suit yourself, or use part of a painting rather than the entire piece. For instance, you could paint only the mill on a small canvas, and leave out the rest, or paint it in a different season. Be creative and see what you can do that is similar yet different. Have fun!

Let's go down by the Mill
Where kids sometimes play,
And swim in cool, clear water
On a hot July day.

We could take a little dip,
Or might just bring a pole,
To catch a slippery fish
From the old swimming hole.

D. Dent

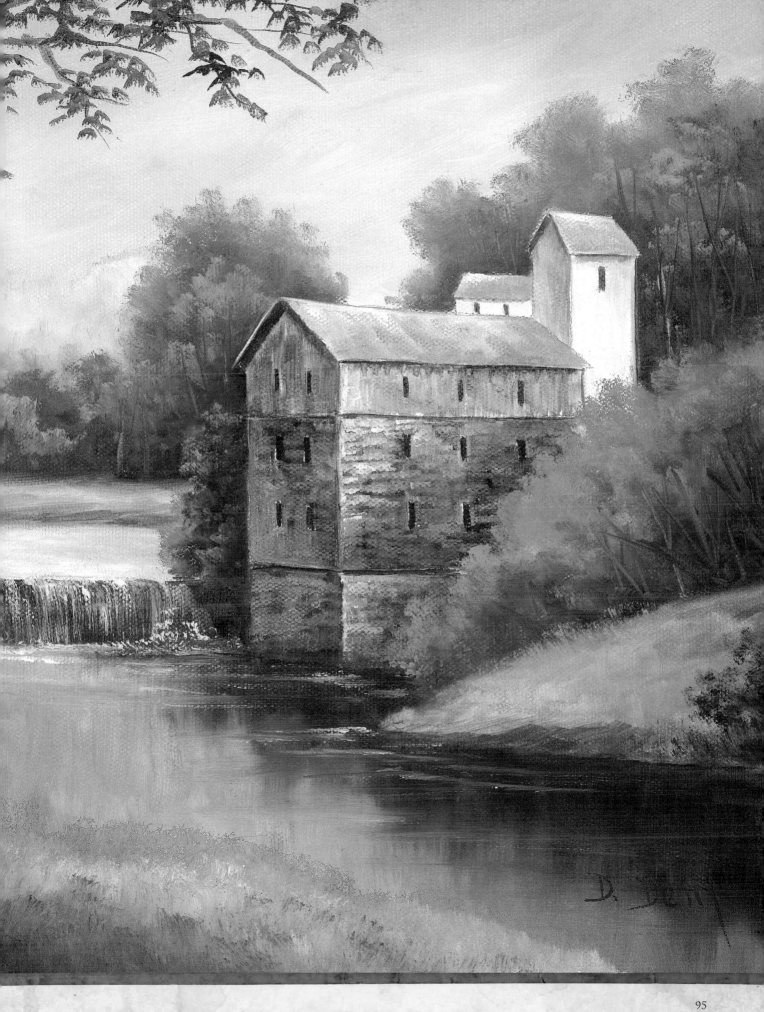

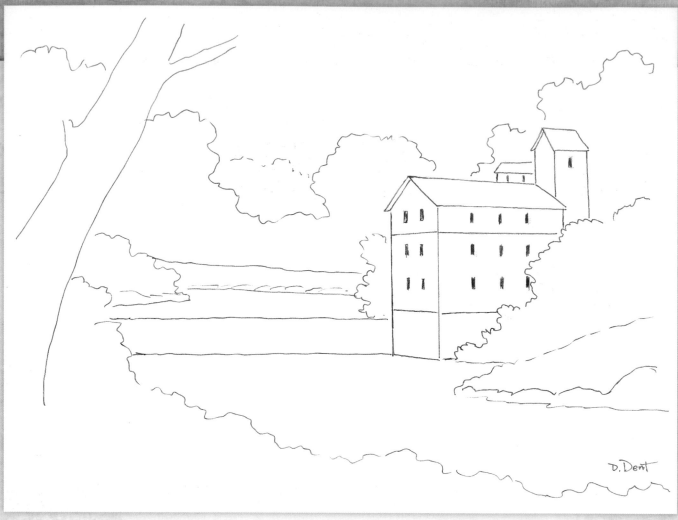

This pattern may be hand-traced or photocopied for personal use only. Enlarge first at 200% and then at 104% to bring it up to full size.

Materials List

Surface
Stretch canvas, 12" × 16" (30cm × 41cm)

Dorothy Dent Brushes
Small background (no. 6 bristle flat)

Detail flat (no. 8 sable flat)

Filbert (no. 4 sable filbert)

Twiggy liner (no. 1 sable liner)

Foliage fan (no. 4 bristle fan)

Martin/F. Weber Museum Emerald

Brushes
No. 6 synthetic filbert, series 6204

Medium
Martin/F. Weber Liquiglaze

Other Materials
Odorless turpentine (for rinsing and cleaning brushes)

Rinse basin

MARTIN/F. WEBER PROFESSIONAL PERMALBA ARTISTS OIL COLORS

Alizarin Crimson

Cadmium Yellow Medium

Dioxazine Purple

French Ultramarine Blue

Naples Yellow

Paynes Gray

Raw Umber

Titanium White

Yellow Ochre

Seeing With the Artist's Eye

A good composition is a must for a painting to be interesting. The large tree in the foreground sets the mill back in the painting and balances the composition. When you have a large tree with foliage in the foreground, be sure the foliage overlaps the middle of the canvas at the top. If the foliage is all on one side, you will cut the painting in two pieces.

Create good contrast between light and dark at the corners of the building so it won't look flat. You can go back and add dark or light values as many times as you need to until you get the look you like. Use small brushes with sharp edges when painting detail. A fuzzy, worn-out brush doesn't work in small places.

Note that the water over the dam is falling straight down. We are looking straight at thc falls, so don't make the water curve to the side.

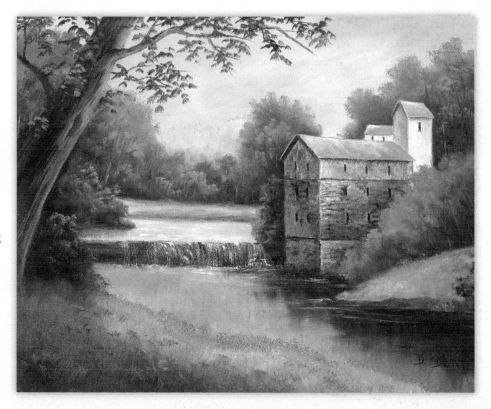

1

2

3

1. PAINT THE SKY

With the small background brush, mix Titanium White + French Ultramarine Blue + a touch of Dioxazine Purple and fill in the sky. This is a very plain sky with no clouds so just fill it all in. Use a little medium to help move the paint on the canvas. Paint down to the tree line. It's OK if you paint out the branches on the large tree to the left.

2. BLOCK IN THE DISTANT TREE LINE

Start at the top of the distant tree line and fill in the bright area with a mix of Titanium White + Naples Yellow + a touch of Yellow Ochre. Then mix a little Alizarin Crimson + Naples Yellow and place this color directly below the bright yellow area.

3. BASE THE TREES AROUND THE MILL

Pick up more Naples Yellow + Alizarin Crimson and work up toward the top of the trees around the mill. The colors can vary a bit, sometimes more toward the red and sometimes more toward the Naples Yellow. Work on the bottom of the small background brush with a bouncy stroke that scoots to the right a bit.

As you move toward the bottom of the trees, pick up some Raw Umber and mix it with the Alizarin Crimson to make a darker color. Some of this darker color will move up over the light area, but be careful not to lose all of your light areas. Work carefully around the buildings, using a detail flat brush to preserve the lines.

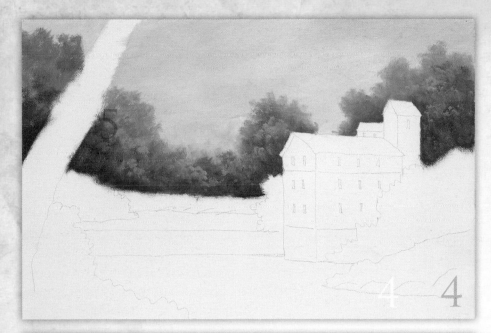

4. TAP IN HIGHLIGHTS ON THE TREES

Add some highlights with Naples Yellow and Yellow Ochre. Let this paint be a little thicker than the paint used in previous steps. Load the corner of the small background brush and tap in the color to create groups of foliage and clusters of highlighted leaves. You can add additional dark values with Raw Umber if you need more contrast with darker values.

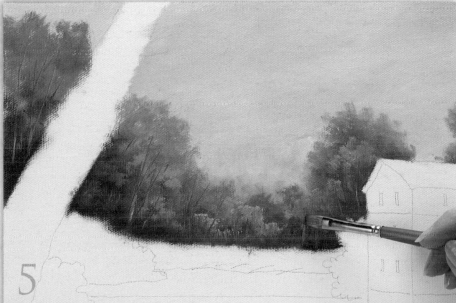

5. LIFT OUT LIMBS

Dip a clean detail flat brush in turpentine and then wipe the turpentine out of the brush. Drag the chisel edge of the brush up through the wet foliage to lift out some of the paint and create the appearance of tree trunks and branches. This will also move some of the dark values up into the light areas.

6. PAINT THE DISTANT BANK

Paint the distant bank with the detail flat brush and pure Naples Yellow. As you work along the tree line, catch some of the foliage color and pull it down onto the bank to soften the line between the two areas.

Shade the dirt bank directly above the water with Raw Umber + a touch of Alizarin Crimson.

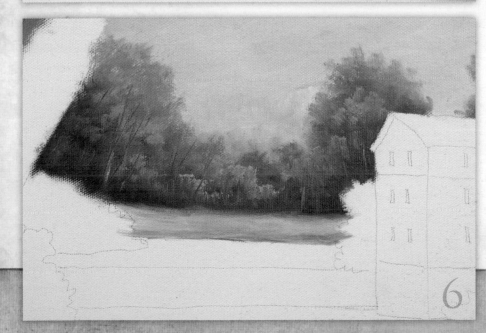

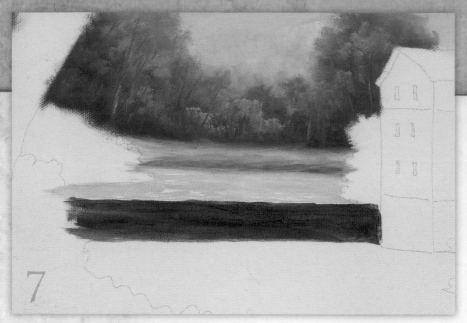

7. BLOCK IN THE UPPER WATER AND THE DAM

With the detail flat brush, mix Titanium White + French Ultramarine Blue + Dioxazine Purple to create a soft, light-value blue. Fill in the water above the dam with soft back-and-forth strokes. Once the area is filled in, pick up some extra Titanium White (a bit thicker) and place small ripple lines to suggest motion in the water.

Fill in the dam with a dark mixture of French Ultramarine Blue + Raw Umber.

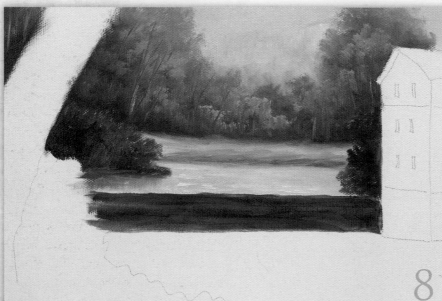

8. PLACE THE SMALL BUSHES

Fill in the small, mid-ground bushes behind the mill and the bushes across from the mill with a mixture of Raw Umber + French Ultramarine Blue. Use the detail flat brush for this small area. Wipe your brush then pull a little of the bush color down into the water and lightly stroke across it under the left bush only.

9. HIGHLIGHT THE SMALL BUSHES

Highlight the bushes with the corner of the small background brush. Mix Cadmium Yellow Medium + French Ultramarine Blue + a touch of Titanium White to create a soft yellowish green. Tap in the green foliage and keep the paint on the top corner of the brush, creating clusters of lighter leaves.

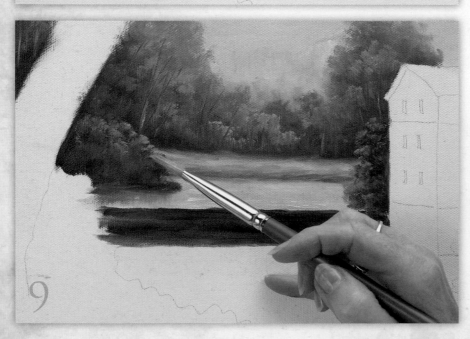

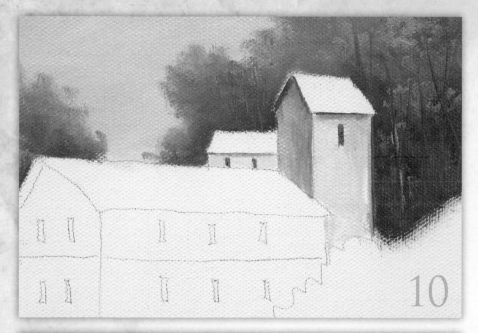

10. BLOCK IN MILL TOWERS

Switch to the detail flat brush to paint the mill. Mix Titanium White + a touch of Raw Umber + a touch of French Ultramarine Blue to create a gray color. Paint the dark gable side (left side) of the mill's tower with this mix. Use the same mix for the right side of the tower but with more Titanium White added to lighten the value. Be sure there is plenty of contrast at the corners. Run a darker line of Raw Umber under the roof edge. The little building behind the tower is the same color as the tower with more Titanium White.

Add the windows with the twiggy liner brush and Raw Umber.

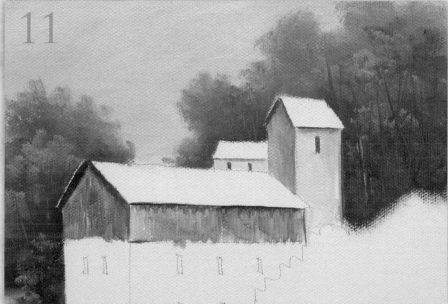

11. PAINT THE RED WALLS

Still using the detail flat brush, mix Alizarin Crimson + a touch of Raw Umber and thin it with medium. This will be a transparent color. Start by placing a line of this color beneath the roof of the red building and then pull down. As you approach the corner pick up a little Titanium White and Naples Yellow in your mix so the corner looks sunny.

Paint the gable end with the same color only slightly darker. You may need to darken the trees where they touch the building to create more contrast.

12. BASE THE STONE WALLS

Thin Raw Umber with medium and basecoat the two lower stone levels of the mill still using the detail flat brush. Work around the windows. Make the area next to the bushes darker for more contrast and shadows.

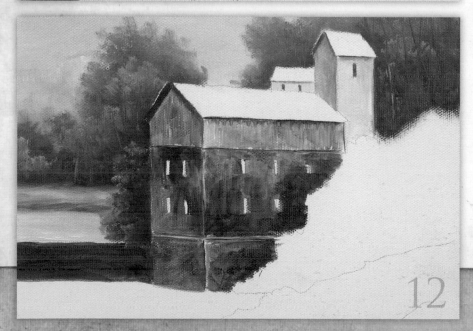

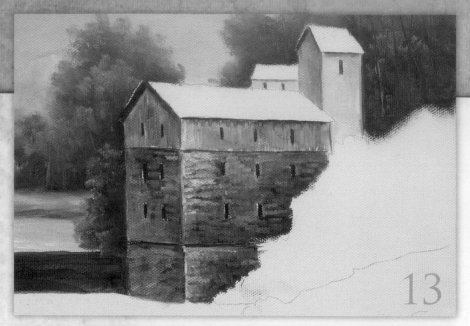

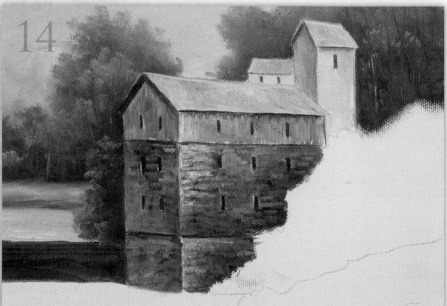

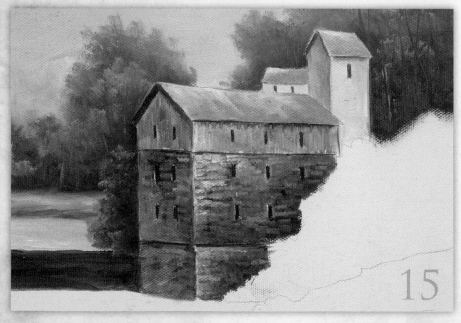

13. ADD STONES TO THE WALLS

Still using the detail flat brush, mix French Ultramarine Blue + Titanium White and use short, patting strokes in the dark area to suggest stones. As you move out farther into the sunlight pick up more Titanium White and some Yellow Ochre and pat on more stones. As you work in the middle corner pick up more Titanium White to really emphasize the sunlight.

On the shadowed side (left side) use only blue-gray for the stones (French Ultramarine Blue + Titanium White). Watch your corners for contrast. You need to have a light side and a dark side. Paint the dividing lines between the sections with Raw Umber. Paint the windows with the twiggy liner and Raw Umber.

14. PAINT THE ROOFS

Basecoat the roofs with a coat of Naples Yellow, thinned with medium. Use the detail flat brush for this area.

15. DETAIL THE ROOFS

Mix French Ultramarine Blue + Titanium White + a touch of Dioxazine Purple. Load a very small amount of this color on the detail flat brush and brush the color on the lower part of the roof following the slope of the roof. The light blue will turn greenish when you place it on the Naples Yellow basecoat. You might want to add tiny touches of Titanium White in places to soften the yellow at the top of the roof.

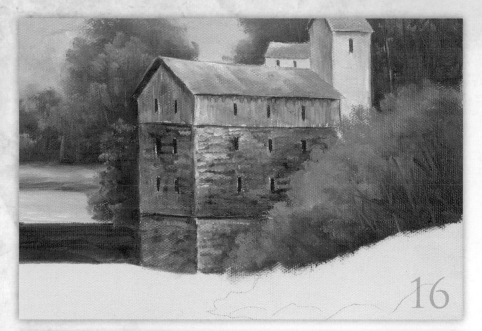

16. PAINT THE BUSH IN FRONT OF THE MILL

Switch to the small background brush. Mix Naples Yellow + Alizarin Crimson and pat in the bush in front of the mill. Start at the top and use the corner of the brush, keeping the paint on top of the bristles. Go out a bit past the line where the bush and building meet so the foliage touches the building a bit and the edges look uneven like real foliage. As you move down the bush pick up more Alizarin Crimson and some Raw Umber, as you did with the background trees.

Use the side of a clean detail flat brush and lift out some twigs and limbs as you did with the background foliage.

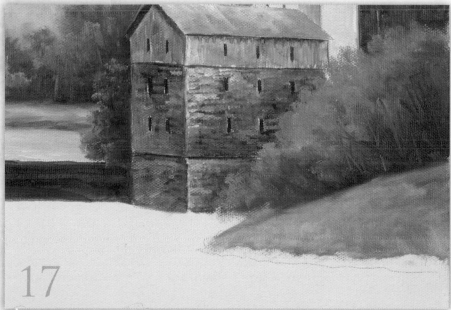

17. BLOCK IN THE FOREGROUND

Switch back to the small background brush. Basecoat the ground under the bush with Naples Yellow. Swish in the color and pick up a little of the bush color near the line where the bush and foreground meet to blend the areas together. Pick up some French Ultramarine Blue mixed with Naples Yellow and brush it on the right side of the ground to create a green color.

18. BASECOAT THE BANK

Basecoat the bank beneath the grass with Raw Umber + a touch of Alizarin Crimson. Brush the color back in following the slope of the hill. Use the same mixture and tap in a bush in the corner of the canvas using the corner of the small background bush. Try to make the bush irregular so it's not just a little round ball.

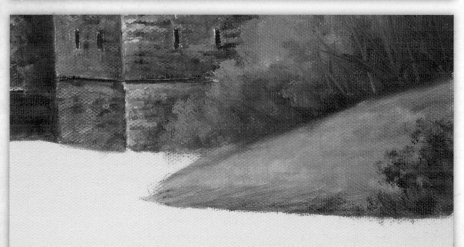

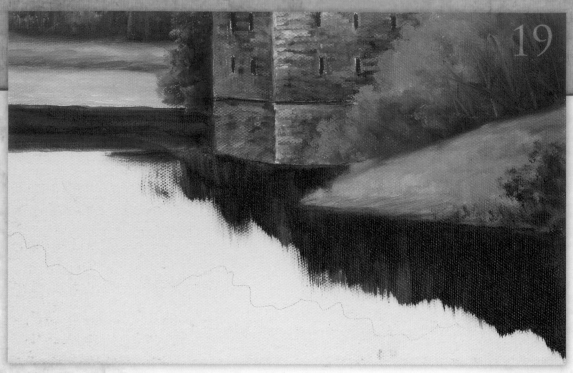

19. PLACE DARK VALUES IN THE WATER

Using the small background brush, cut Raw Umber + Alizarin Crimson in the water directly under the mill, under part of the dam and under the right-side bank. Then pull the color all the way down to the grass using only vertical strokes. The entire right corner is very dark.

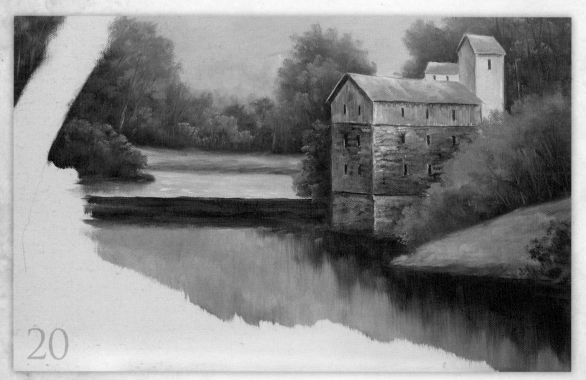

20. PAINT MORE WATER

Clean the small background brush and mix Titanium White + French Ultramarine Blue + Dioxazine Purple. Make this mixture a little darker than the water above the dam. Place this color beneath the water's dark value and stroke up and down. Brush up into the dark value so you blend some of the color. Use a little medium to help move the paint on the canvas.

Pick up a little extra Raw Umber and place it on the bottom section of the mill where it touches the water to help set the mill down on the water.

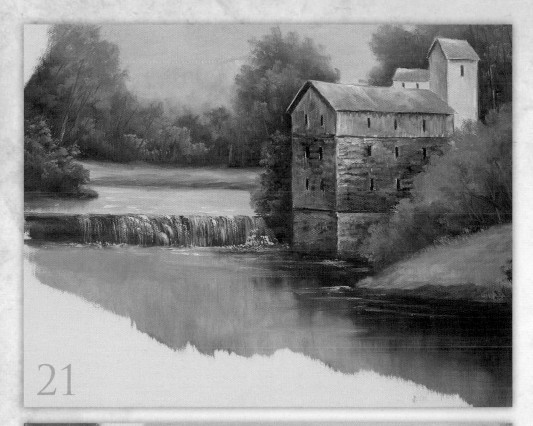

21. ADD FALLS AND MOVEMENT TO THE WATER

Load the corner of the foliage fan brush with Titanium White. Place the brush just above the dam and drop the white water over it. Let a lot of the dam show through. You don't want to cover up all of it. Then tap a bit of foam under the dam with the corner of the brush and pull the foam off to the side.

Use the foliage fan brush to lightly pull across all of the water to distort it. Occasionally add some streaks of Titanium White for ripples. You can also use the detail flat brush and a little Titanium White to add movement lines.

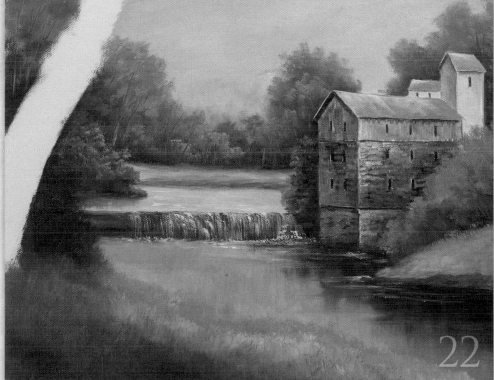

22. BLOCK IN THE LEFT BANK

Switch to the small background brush. Mix Paynes Gray + Raw Umber and use the corner of the brush to block in the bush next to the large tree.

Switch to the foliage fan brush and mix Naples Yellow + Yellow Ochre + a touch of Titanium White. Block in the grass on the left bank with short, downward strokes. Use a little medium to help move the paint on the canvas. As you move down and to the left, pick up some French Ultramarine Blue in the grass mix for a green color. As you get closer to the lower corner pick up even more French Ultramarine Blue + a little Raw Umber so the corner is very dark.

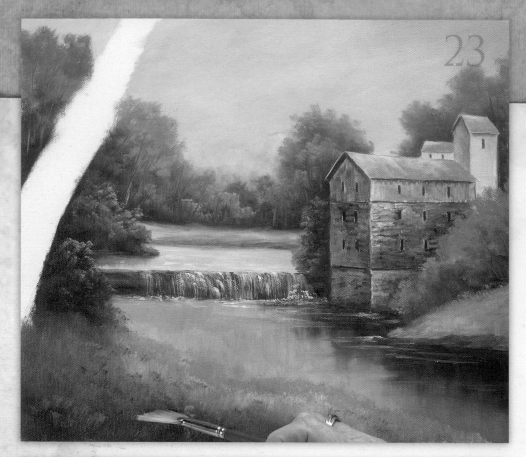

23. HIGHLIGHT BUSH, TEXTURE THE GRASS

Switch to the foliage fan brush. Load the corner of the brush with Naples Yellow + a touch of Alizarin Crimson and highlight the bush and add texture to the grass. Keep the paint on top of the bristles and use a small, downward flick of the wrist to make the stroke.

24. PAINT THE TREE TRUNK

Switch to the small background brush and base the tree on the left with Raw Umber. Pick up some Yellow Ochre + Titanium White as you move to the right side of the trunk. Use just enough medium to help move the paint. Don't worry if the paint looks streaky, as the streaks will look like bark texture.

Add the limbs with Raw Umber using the detail flat brush for the larger branches and the twiggy liner brush for the smaller ones. Be sure to thin the paint with turpentine for the linework.

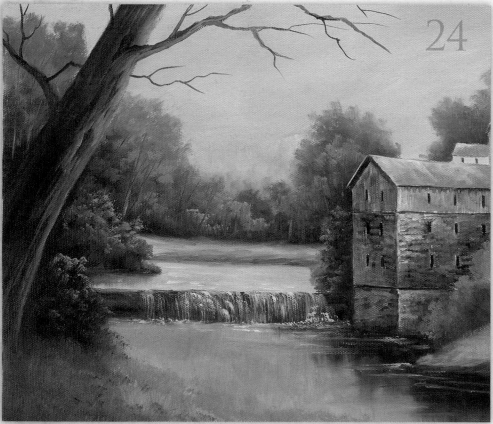

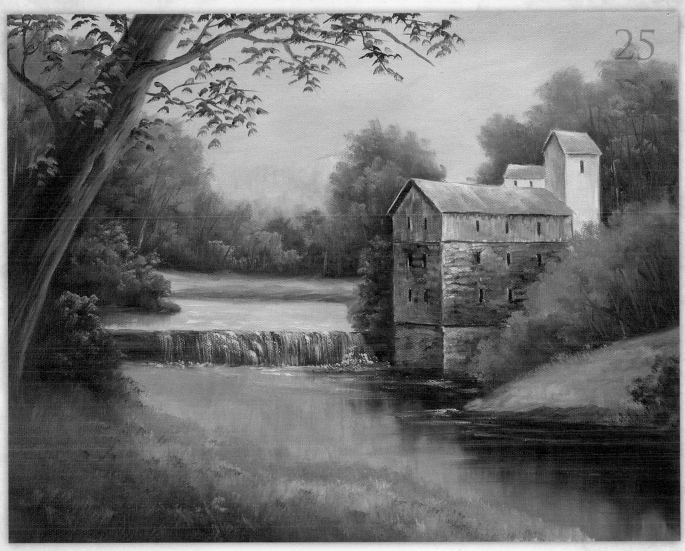

25. ADD THE LEAVES

Use the filbert brush to paint the leaves on the large tree. Start with Raw Umber + Alizarin
Crimson and then add some Alizarin Crimson + Naples Yellow. See page 17 for detailed
instructions on this technique.

CLINTON MILL

This painting was done from a photo someone gave me of Clinton Mill in New Jersey. I have never been there, but perhaps I will get to see it in person someday. You will get lots of practice painting background trees with this project, and it will be fun to work with the great fall colors. The light is coming from the left in this painting, so think of where the shadows will fall on the building as well as on the ground and water.

You will also get to practice painting a rock wall, and I think you will find it is very easy to do. The rocks are simply little "scoots" of paint on top of the dark basecoat.

Who wouldn't love a big red mill
With a wheel going round and round?
It's churning and moving the water
With a joyful, splashing sound.

It's grinding up the corn
With the spinning of the wheel.
Let's buy a nice, big sack full
Of that freshly ground cornmeal!

D. Dent

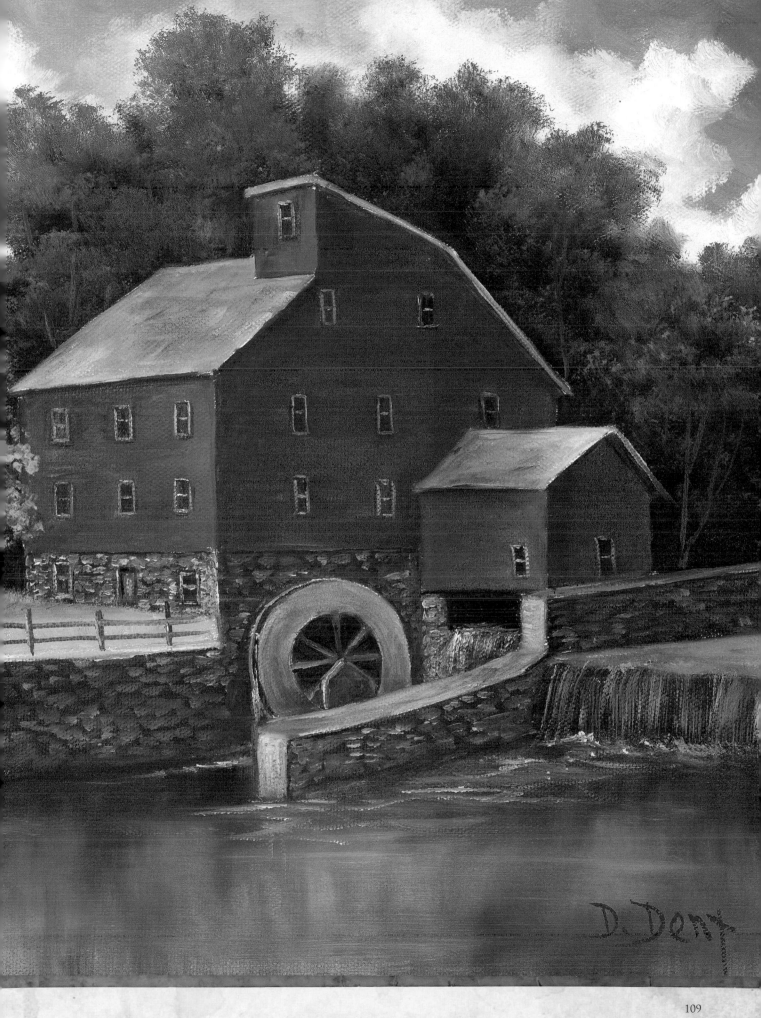

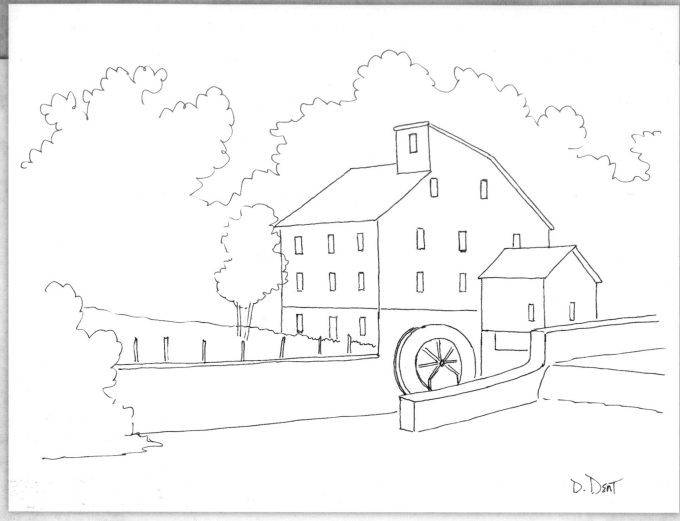

This pattern may be hand-traced or photocopied for personal use only. Enlarge first at 200% and then at 104% to bring it up to full size.

Materials List

Surface
Stretch canvas, 12" × 16" (30cm × 41cm)

Dorothy Dent Brushes
Small background (no. 6 bristle flat)

Detail flat (no. 8 sable flat)

Twiggy liner (no. 1 sable liner)

Filbert (no. 4 sable filbert)

Foliage fan (no. 4 bristle fan)

Medium
Martin/F. Weber Liquiglaze

Other Materials
Odorless turpentine (for rinsing and cleaning brushes)

Rinse basin

MARTIN/F. WEBER PROFESSIONAL PERMALBA ARTISTS OIL COLORS

Burnt Sienna

Cadmium Orange

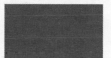
Cadmium Red Light

Cadmium Yellow Medium

Dioxazine Purple

Indanthrone Blue

Paynes Gray

Titanium White

Venetian Red

Yellow Ochre

Seeing With the Artist's Eye

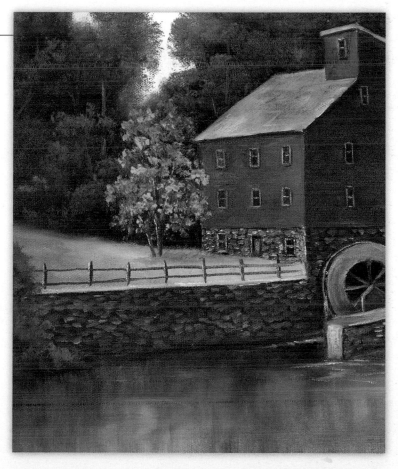

The cheerful, bright colors in this painting make it appealing to look at. I like the way the little yellow tree by the mill overlaps the building a bit. That little touch sets the mill back behind the tree.

The reflections in the water add much more interest than if they were left out. Reflections don't have to be detailed—just pulling some of the same general color that is above the water down into the water is enough to do the trick.

Painting foliage can cause problems for students. Often they lose too much of the dark basecoat because they work too much light into the leaves and end up with a flat, overworked look. You want to end up with light, medium and dark values for depth in the trees. Brighter colors are put on with more paint. Medium values will occur if you lift up on the pressure of the brush and allow the brighter color on the brush to blend in with some of the dark basecoat. The dark is simply the dark basecoat that you won't cover entirely.

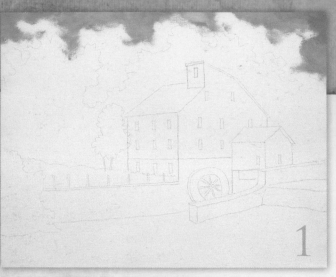

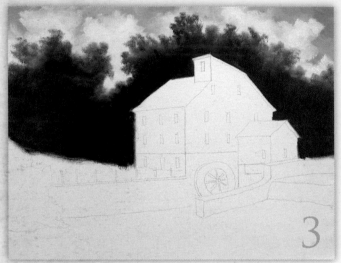

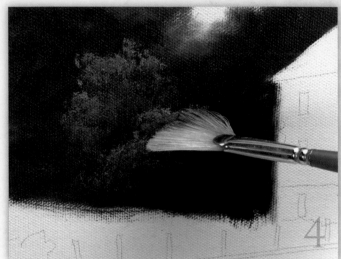

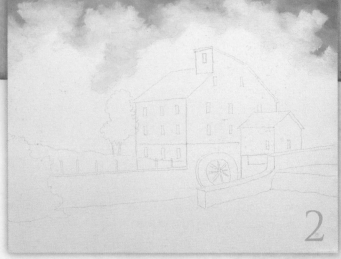

1. PAINT THE BLUE SKY
Use the small background brush to paint the sky. Mix Titanium White + Indanthrone Blue + a touch of Paynes Gray and fill in the sky area. Be careful not to fill in the cloud area. Use a little medium to help move the paint.

2. PAINT THE CLOUDS
Clean the brush and paint the clouds with Titanium White + a touch of Yellow Ochre to create an off-white color. Work on the bottom of the brush and overlap the blue a bit on the canvas to pull some of the color into the clouds. These clouds can come down into the trees a bit.

3. BASECOAT THE DISTANT TREES
Working with the small background brush, basecoat all of the background trees with Paynes Gray + Burnt Sienna. This should be a very dark black color. Be careful not to get too much Burnt Sienna in the mix or it will look too brown. Stretch out the paint with a little medium so you can paint over it easily to add the colorful foliage. Using the detail flat brush, carefully work the dark mix around the building so you don't lose your transfer lines. Be sure to soften the outer edges of the trees to create the look of foliage against the sky.

4. ADD THE BRIGHT FOLIAGE AND LIMBS
Use the foliage fan brush to apply the foliage highlights. Create autumn colors for the foliage using various mixes of the following colors: Yellow Ochre, Cadmium Orange, Cadmium Yellow Medium and Cadmium Red Light.

Keep the paint on the top corner of the foliage fan brush. Create an edge on a cluster of foliage and then work in, letting the color fade back as you move away from the edge. You can fade the color by using less pressure on the brush. Be sure to keep some of the dark color between the groupings of foliage. See page 16 for more instruction on this technique.

5. FINISH THE FOLIAGE
You can go back and add a brighter edge in front of the muted edges to create shape and form within the foliage. Use Cadmium Yellow Medium to create the bright yellow foliage on the left side of the mill. (*Continued on page 113.*)

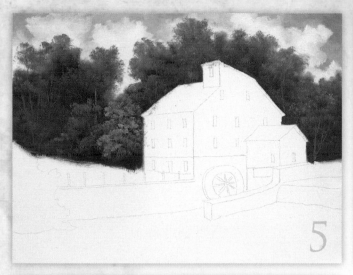

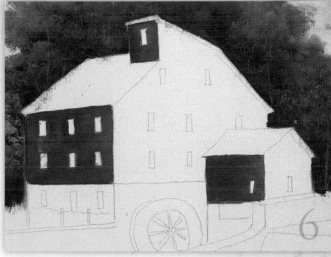

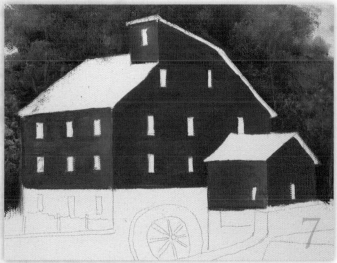

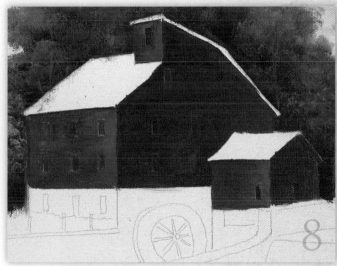

(*Step 5 continued*) Place the limbs with a twiggy liner brush. Mix Burnt Sienna + a touch of Cadmium Orange + a touch of Titanium White, and thin the paint with turpentine. Thread the limbs through the foliage. You don't need a lot of limbs, just enough to establish the general look of trees.

6. BASE THE LIGHT SIDE OF THE MILL

Switch to the detail flat brush to paint the mill. Begin with the light side (the left side). Mix Venetian Red + Cadmium Red Light and paint around the windows. Block in around the windows with the chisel edge of the brush then fill in around the area. As you move across from left to right, pick up some Cadmium Orange in your mixture to simulate the appearance of sunlight hitting the corner of the building. This orange will also create good contrast in the color values and help distinguish the sides of the building. Also paint the upper section of wall that is above the roof and the light side of the building extension that is over the water.

7. BASE THE DARK SIDE OF THE MILL

For the dark sides of the mill use mostly Venetian Red with just a slight touch of Cadmium Red Light and no Cadmium Orange. Continue to use the detail flat brush and paint around the windows.

8. SHADE THE MILL AND ADD WINDOWS

To shade the building, pick up a little Paynes Gray and place it directly beneath the eaves all the way around the building. Soften the edge of the dark into the red on the wall. Also pull a little Paynes Gray across the wall on the darker side to create even more shadow and contrast against the light side. Don't actually make board lines, but if the shading looks a little streaky it will suggest clapboards. Also fill in the overhang on the gable of the building extension.

Switch to the filbert brush and paint in the windows with Paynes Gray + a touch of Burnt Sienna.

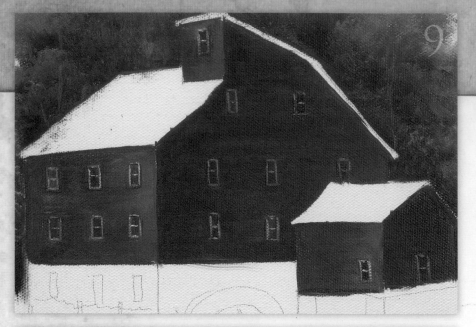

9. DETAIL THE WINDOWS

Load the twiggy liner brush with Titanium White + a touch of Paynes Gray thinned with turpentine and place an edge of white around the windows to create a frame. Add a little more Paynes Gray to the windows on the right side as they are in shadow. Place the pane lines through the center of the window with the same mix.

When the frames are placed, clean the brush, load it with thin Paynes Gray and place a shadow under the frames. On the left side of the building also add a shadow to the right of the frames. On the right side of the building place the shadow on the left side of the frames.

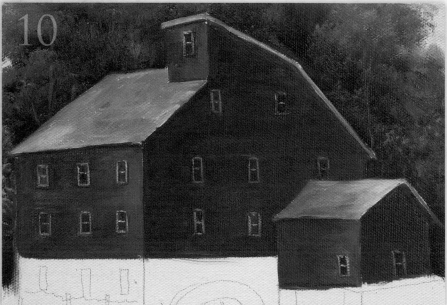

10. PAINT THE ROOF

Switch to the detail flat brush to paint the roof sections. The roof sections are fairly light to contrast with the dark foliage behind them. Mix Titanium White + a touch of Burnt Sienna + a small touch of Paynes Gray for the roof color. Vary the colors, making some areas lighter and some areas darker to create a textured feeling.

Make the roof on the building extension a little darker where it meets the wall of the main building and lighten the color as it moves out to the right. Don't forget the edge on the other side of the gable end or the backside edge of the roof on the main building.

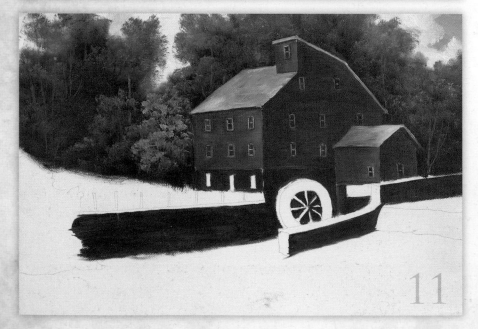

11. BASE THE FOUNDATION AND THE STONE WALLS

Basecoat the mill's foundation and the stone walls with Burnt Sienna + Paynes Gray using the detail flat brush. Use a little medium in the paint—just enough to thin it so it will move. Leave the top edges of the long wall and the short retaining wall unpainted. Use the filbert brush to fill in between the spokes of the waterwheel with the same dark color.

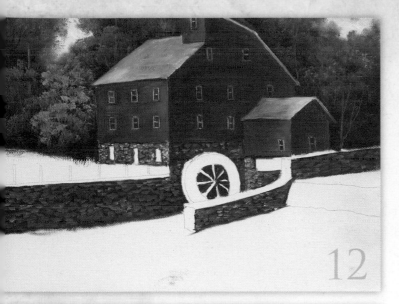

12. ADD STONES TO THE FOUNDATION AND WALLS

Paint the stones in the foundation and walls with the filbert brush. Mix Yellow Ochre + Burnt Sienna + a touch of Titanium White to create a tan color for the stones. Use small strokes with just enough paint to make the stones. These are fieldstone so they don't need to be laid in a straight line. Start in the center and work out to avoid straight lines.

The stones on the left side of the building are the lightest. All of the others will be in shadow. Simply use less paint for the shadow side so you don't see them as well. You can even add some Indanthrone Blue to the mix to gray down the color in shaded areas. Make sure you have contrast at each corner, light against dark, so the foundation walls have the proper shape and form.

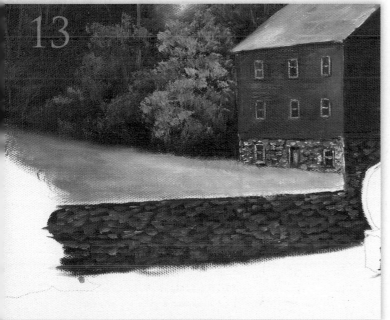

13. DETAIL THE FOUNDATION AND PAINT THE GRASS

Finish the windows and the door in the foundation of the building by filling them in with the filbert brush and Paynes Gray + Burnt Sienna. Add the frames and panes to the windows as you did in Step 9. After you fill in the door, highlight it with some streaks of dirty white.

To paint the grass, switch to the small background brush and mix a soft green with Cadmium Yellow Medium + Titanium White + a touch of Indanthrone Blue. Start on the left side of the grass. Paint out the fence posts and soften the color into the background tree line, blurring the edge there. As you approach the building, pick up some Yellow Ochre and more Titanium White in your dirty brush and blend back into the green on the left side of the canvas.

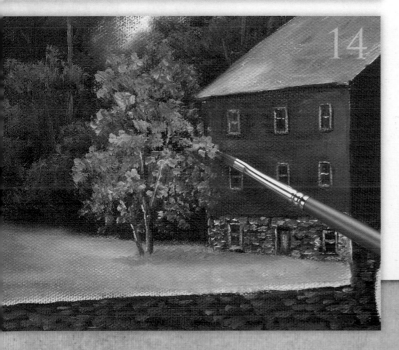

14. DEVELOP THE YELLOW TREE

Add more foliage as needed to the yellow tree next to the mill using the filbert brush and Cadmium Yellow Medium, and/or a little Cadmium Yellow Medium + Titanium White. The foliage should come down into the grass a bit, and overlap the corner of the mill. The paint should be somewhat thick.

With the twiggy liner brush, mix Paynes Gray + Burnt Sienna and add a few small trunk lines under the tree. Bring these trunks up into the foliage. Then, using the detail flat brush, pat some of the dark color onto the grass around the trunks and to the left to create a shadow to set the tree down into the ground. Highlight the left side of the trunk with Titanium White to make it more visible.

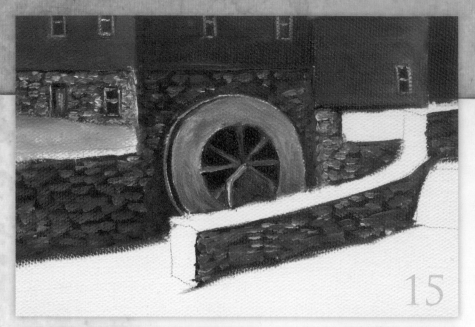

15. PAINT THE WATERWHEEL

Moving on to the mill wheel, paint the dark sliver you can see on the left side with Paynes Gray using the filbert brush. Leave just a tiny edge for the rim. This color tapers off at the top.

For the outer edge create a dirty white (Titanium White + a touch of Burnt Sienna) and use the twiggy liner brush to paint the rim.

Paint the flat side of the wheel and the spokes with a light value of Burnt Sienna + a touch of Titanium White. Thin the paint a bit with medium so it goes on easily and is visible. Make the value a little darker toward the bottom of the wheel using more Burnt Sienna + a touch of Paynes Gray.

Fill in the little support to the side of the wheel with Paynes Gray and bring it right up to the hub of the wheel. Add a little Titanium White + Burnt Sienna highlight on the left side of the support.

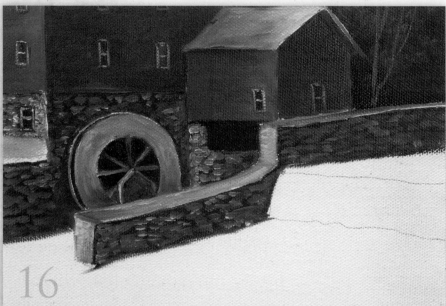

16. PAINT THE TOPS OF THE SHORT WALL

Switch to the detail flat brush. Block in the dark opening under the small part of the mill with Burnt Sienna + Paynes Gray. Paint the top of the wall Burnt Sienna + Paynes Gray + Titanium White so it is lighter than the stone side. Add a little Cadmium Orange + Titanium White to the end caps of the lower and upper wall.

17. PAINT TOP OF THE LONG WALL, ADD THE FENCE

Paint the top edge of the wall along the grass with Titanium White + a small touch of Cadmium Orange. Use a twiggy liner brush to place the fence posts with thinned Burnt Sienna + Paynes Gray. (Continued on page 117.)

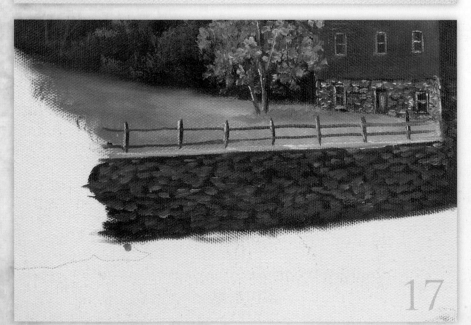

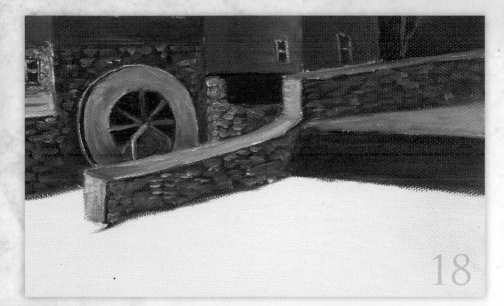

(*Step 17 continued*) Refer to the photo if you can no longer see your transfer lines. The small rails will go across the posts. Highlight the fence with Titanium White on the left side of the post if needed. The Titanium White should be next to the dark, not on top of it.

18. BASE THE DAM AND UPPER WATER

Basecoat the dam with Paynes Gray. Paint the water above the dam with Titanium White + Paynes Gray + a touch of Indanthrone Blue. Bring this color down to the top of the dam for now.

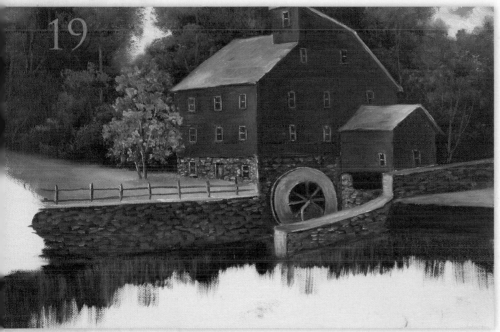

19. ADD THE DARK WATER

Switch to the small background brush and lay in some Paynes Gray + Indanthrone Blue + a touch of Burnt Sienna + medium directly beneath the rock wall and dam using vertical strokes. Also place this mixture under the long rock wall and under what will be a bush on the far left side. Don't pull down too far, about 1 to 1½ inches (3cm to 4cm), to save room for other colors.

20. ADD LIGHT WATER

Add some Titanium White to the Paynes Gray + Indanthrone Blue. Place your small background brush just beneath the dark water and pull up and down vertically to overlap the lighter color into the dark color. Again, leave room for other colors in the water.

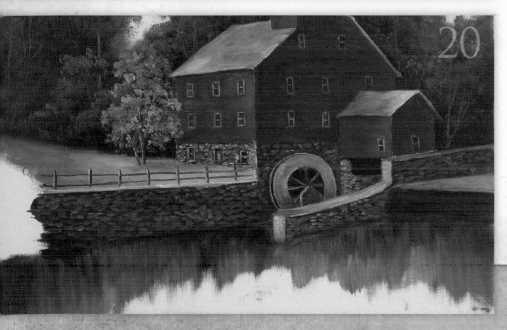

21. ADD REFLECTIVE COLORS TO WATER

With a clean small background brush pick up some colors that would reflect into the water, such as the mill colors—a little bit of Cadmium Red Light and Venetian Red. If this reflection color looks too bright, just pull some of the blue water down over it. As you move to the left, clean your brush and pick up some Cadmium Yellow Medium to reflect the yellow tree. Blend this color with the colors around it, but get out of the color before you over blend it.

22. DISTORT WATER AND CREATE THE FALL OVER THE DAM

Run a clean, dry foliage fan brush across the water horizontally to slightly blend and distort the colors. Now pick up some light blue (Indanthrone Blue + Titanium White) on the foliage fan brush. Use only about one-half of the brush to drop some water over the dam. Bounce the corner of the brush along the bottom of the dam to create foam patterns. Sweep in more wiggly strokes beneath the dam to show movement.

23 ADD MORE MOVEMENT LINES

Use the corner of the foliage fan brush and the light blue mixture to pull just a little bit of water from the dark opening beneath the building extension. (Continued on page 119.)

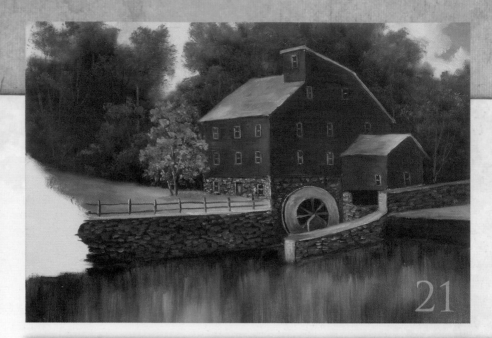

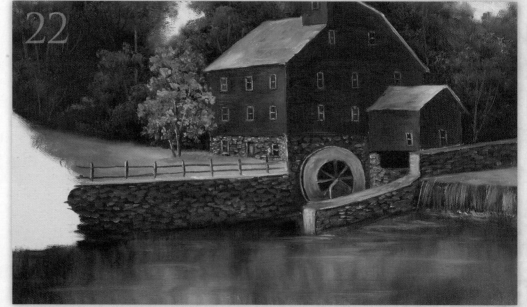

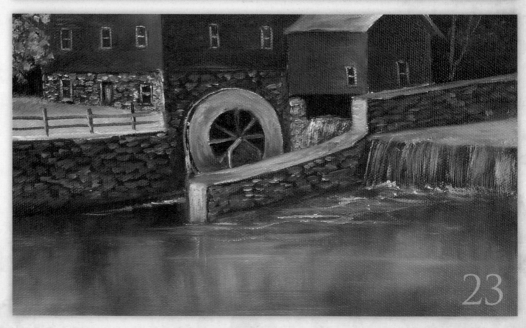

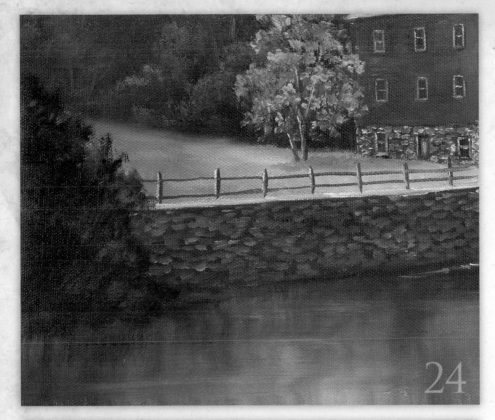

24

(*Step 23 continued*) Use the twiggy liner brush to pull a few drips of water off the wheel. Also pick up more Titanium White on the detail flat brush and add more movement lines to the water under the dam.

24. BLOCK IN THE BUSH

Use the small background brush to block in the bush on the left with Paynes Gray + Burnt Sienna.

25. HIGHLIGHT THE BUSH

Load the corner of the foliage fan brush with Cadmium Orange + Yellow Ochre and tap highlights on the bush. Then pull a little of this color down into the water around the bush for reflections and lightly distort by sweeping across the reflections.

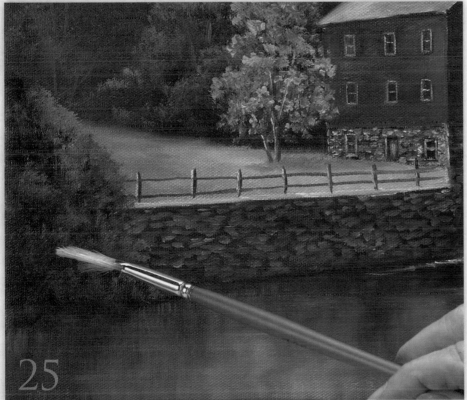

25

9 BURNT COAT LIGHT

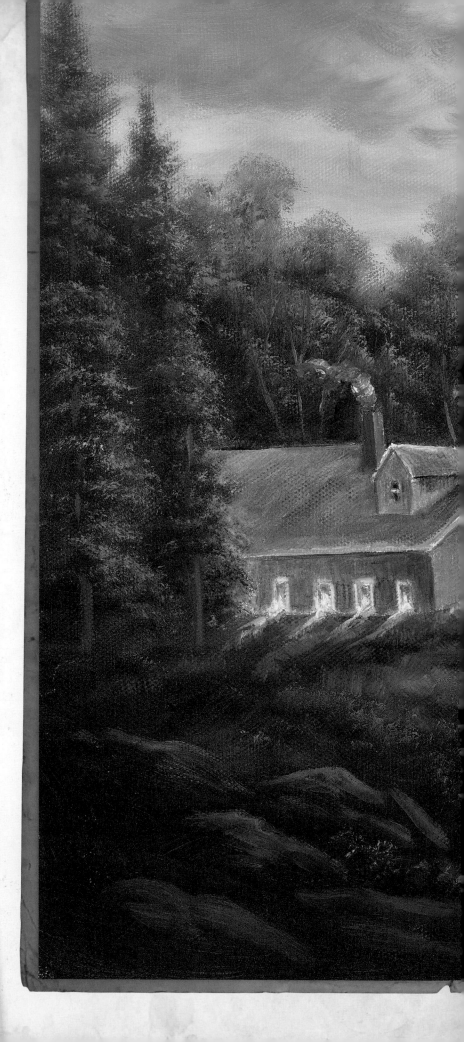

Lighthouses are such popular subject matter that they always attract attention. There is something about light shining out of darkness that has meaning and gives hope to all of us. This painting has a lot of detail, so be sure your brushes are in good shape and are not fuzzy and worn-out.

The photo reference for this painting came from Pat Riley, a painting teacher and friend in Maine. She told me this lighthouse, located off the coast of Maine, is on an island and can only be seen by boat. That's too bad, as it's such a lovely grouping of buildings.

Through the darkness, mist and fog
Shines the welcome beam of light
To warn the ships who struggle through
The treacherous waters late at night.

The Captain sees the beam cast out,
He knows he's safe once more
Thanks to the keeper of the light,
And the lighthouse set upon the shore.

D. Dent

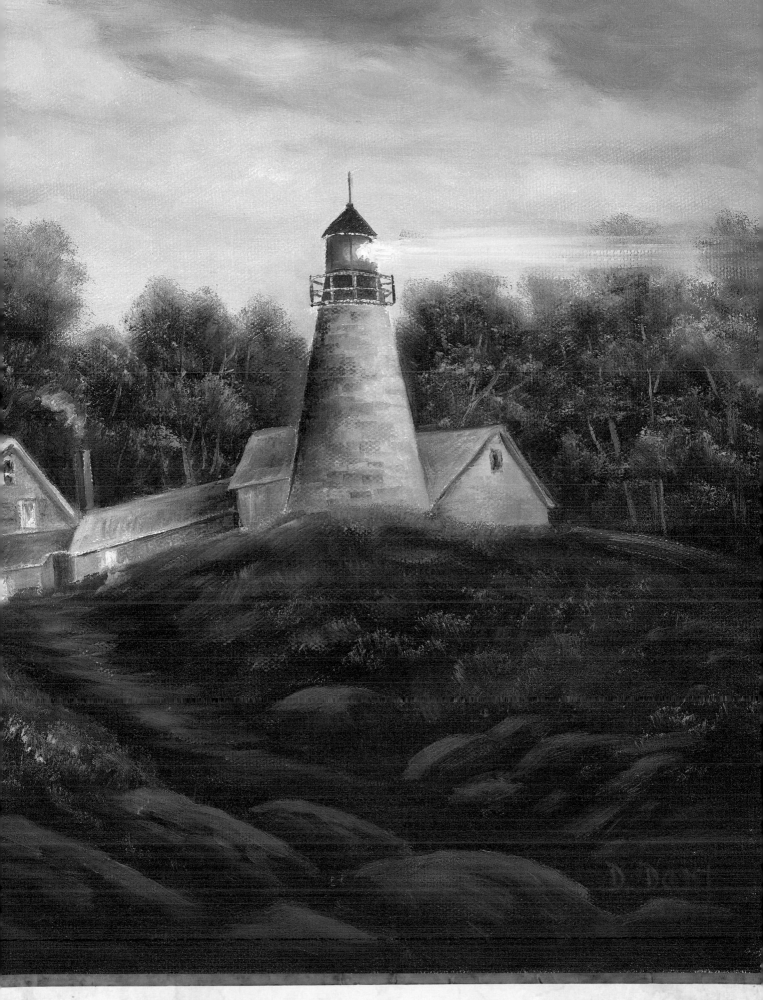

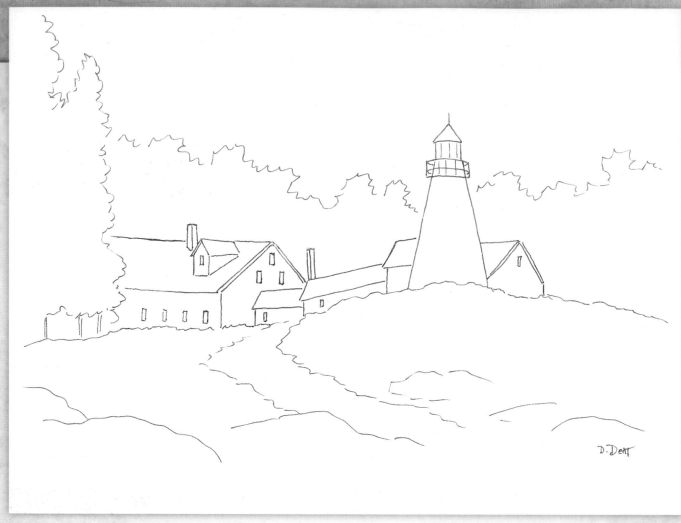

This pattern may be hand-traced or photocopied for personal use only. Enlarge first at 200% and then at 104% to bring it up to full size.

Materials List

Surface
Stretch canvas, 12" × 16" (30cm × 41cm)

Dorothy Dent Brushes
Detail flat (no. 8 sable flat)
Foliage fan (no. 4 bristle fan)
Small background (no. 6 bristle flat)
Filbert (no. 4 sable filbert)
Twiggy liner (no. 1 sable liner)

Medium
Martin/F. Weber Liquiglaze

Other Materials
Odorless turpentine (for rinsing and cleaning brushes)
Rinse basin

MARTIN/F. WEBER PROFESSIONAL PERMALBA ARTISTS OIL COLORS

Alizarin Crimson

Brilliant Yellow Light

Cadmium Orange

Cadmium Yellow Medium

French Ultramarine Blue

Paynes Gray

Raw Umber

Titanium White

Ultramarine Violet

Venetian Red

Viridian

Seeing With the Artist's Eye

The photo I had of this lighthouse was not a nighttime scene. I thought it would be more interesting to make it dark so the light from the tower would show up nicely. Don't be afraid to change the time of day when painting from photographs. Use your imagination to create different settings for buildings, different seasons or different lighting. You may be surprised at what you can do. Have fun with it.

The various elements in the painting need to be tied together in some way. The rocky path leading up to the building ties the foreground to the middle ground. The tall trees to the left help connect the middle ground and background, and their dark value contrasts with the lighter building, and shows it off to good advantage.

Of course, the lights in the windows as well as the tower's beam pull the eye right into the scene. Be sure the light pulled from the tower fades out at the end. Light beams do not have hard edges, nor does light abruptly stop in midair. The light beam is easier to paint after the painting is dry. You can then use thin paint and not worry about picking up too much of the sky color.

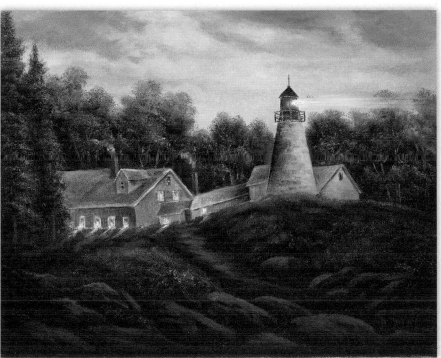

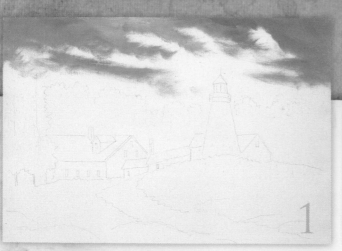

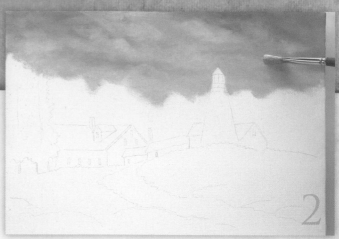

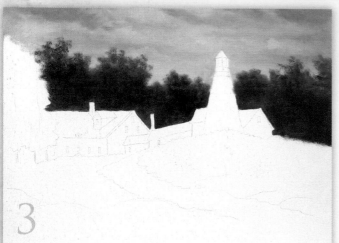

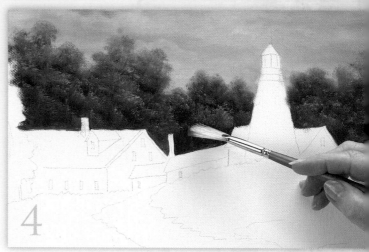

1. BRUSH IN THE SKY

Use the small background brush to base the sky. Keep in mind that this is a late evening scene so you don't want colors that are too bright. Mix Titanium White + Paynes Gray + French Ultramarine Blue + a touch of Raw Umber for the base color in the sky. Don't make the mixture too brown. Keep it toward the gray. The colors will vary a bit in the clouds. As you work the color on the canvas, leave room for the pinker clouds. Use just enough medium to help move the paint. It's OK to paint out the tops of the pine trees if needed.

2. ADD THE PINK CLOUDS

Paint the pink clouds with Titanium White + a touch of Alizarin Crimson + a tiny touch of Paynes Gray. Be sure to work on the corner edge of the small background brush.

Mix Titanium White + a small touch of Ultramarine Violet and work it into the pink on the canvas. Overlap the blue sky with the pink clouds to soften where the two areas meet. Work carefully around the lighthouse tower, but paint out the bars and posts surrounding the light where they stick out over the sky. Check the sky for contrast, and add more dark values with Paynes Gray if needed.

3. BASE THE BACKGROUND TREES

For the background trees, mix Paynes Gray + Raw Umber + an occasional touch of Alizarin Crimson. This basecoat should be very

dark. Begin by using the detail flat brush to work carefully around the edges of the buildings. Apply the rest of the paint with the corner of the small background brush using bouncy strokes that sometimes move to the side. The tops of the trees should be uneven to create trees of different heights silhouetted against the sky.

4. ADD FOLIAGE TO THE TREES

Use the foliage fan brush to place the foliage on the trees. Mix Viridian + Titanium White and occasionally add a touch of Cadmium Yellow Medium. You want just a little green—nothing too bright or it will look like broad daylight instead of evening.

Use the corner of the foliage fan brush and keep the paint on top of the bristles (see pages 15–16). You want the green to pick up some of the dark basecoat. The basecoat will help mute the green and dull it down a bit. Be careful not to lose all of the dark. Only highlight a little, just enough to give the trees shape.

TIP
New brushes will help you to create sharp edges, especially on the corners of the buildings and along the roofline. It is difficult to be exact with old, worn brushes.

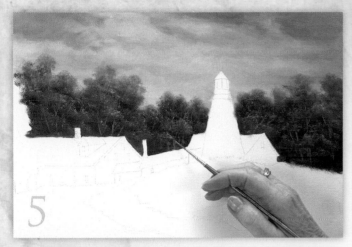

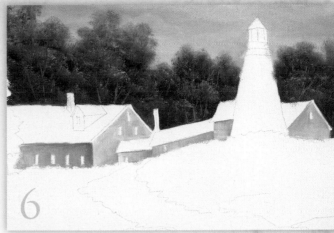

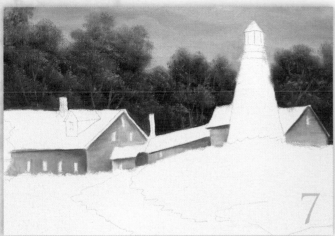

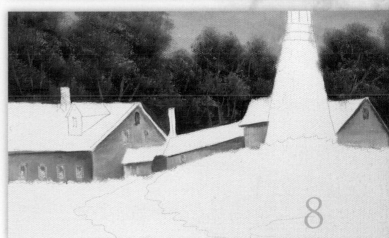

5. PLACE THE TRUNKS AND BRANCHES

Load the twiggy liner brush with Ultramarine Violet + Titanium White thinned with turpentine to an ink-like consistency and place trunks and branches within the foliage. Let the limbs skip in and out of the foliage so it doesn't look like they are all in front of the foliage. Add just a few limbs here and there; you don't want to overdo it.

6. BASECOAT THE BUILDINGS

Use the detail flat brush to basecoat the buildings. Mix Titanium White + a touch of Paynes Gray + a small touch of Alizarin Crimson to make a pinkish gray basecoat color. Occasionally add a small touch of Raw Umber to vary the color a bit. Work around the windows.

It is very important to develop contrast on the buildings. Where two sections of the building meet, there must be a light and a dark touching. The long section of wall is especially dark in the front corner and fades lighter as you paint the wall out to the left.

7. ADD CONTRAST TO THE BUILDINGS

Increase the contrast by adding more Paynes Gray and Raw Umber in the shadow edges—under the roof edges and between the buildings.

8. ADD THE WINDOWS

Use the twiggy liner brush for the windows. Start by picking up some Cadmium Yellow Medium and a little Brilliant Yellow Light. Paint in each lit window with just a few strokes of the brush. The two top windows in each gable end will be dark.

After you place the yellow, add a little Cadmium Orange and stroke downward from the top. Don't lose all of the yellow; try to keep the yellow especially at the bottoms of the windows. Then dip your twiggy liner brush in straight Brilliant Yellow Light (do not thin it) and paint small lines around each side of the windows, leaving just a little dark area to create frames around the window.

Paint the dark windows with Paynes Gray + Raw Umber + Titanium White.

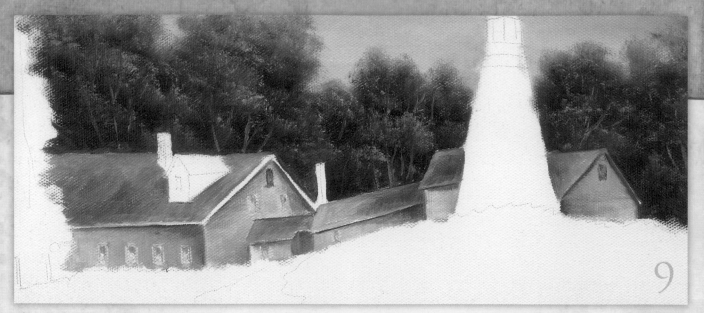

9. PAINT THE ROOFS

Use the detail flat brush for the roofs. Mix Titanium White +
Paynes Gray + Raw Umber + a touch of Alizarin Crimson. Vary
the color mixtures, often picking up more Raw Umber. The roofs
will be darker than the walls. Vary the contrast. Where the roofs
are against the background trees, the roofs should be lighter, so
pick up more Titanium White and even a little Ultramarine Violet
in those areas. Leave the fascia board edge unpainted as you paint
the roofs.

10. PLACE THE DORMER

Paint the dormer using the same colors and techniques used to
paint the other walls (see Steps 6–7). Keep contrast in mind. You
may need to add more dark values on the roof to pull the dormer
away from it. The right side of the dormer should be the lightest
side.

Paint the fascia board with a light value of the purple mix used
on the buildings. Use a twiggy liner brush and thin the paint a bit
with turpentine for easier application.

11. PAINT THE CHIMNEYS

Use the filbert brush to paint the chimneys. The dark sides (left
sides) are Venetian Red + a touch of Raw Umber. Highlight the left
sides with a touch of Cadmium Orange.

The light sides (right sides) are Cadmium Orange + a touch of
Brilliant Yellow Light. If the color looks too bright, add a touch of
Raw Umber to tone it down a bit.

Sometimes it's necessary to knock down some of the green
foliage color in the trees to make the chimneys stand out more. Do
this by patting a clean, dry brush over the area and let the colors
fade gradually.

For the chimney smoke, pick up a little Titanium White on the
bottom corner of the detail flat brush and make small, circular
strokes. Start above the chimneys and work down to them. Make
sure the smoke from the two chimneys blows in the same direc-
tion.

12. ADD LIGHTHOUSE CAP, START THE GLOBE

Use the filbert brush to paint the cap of the lighthouse tower with Paynes Gray + a touch of Raw Umber. The bottom of the cap is slightly curved because you are looking up at a round object. Use the liner to place the lightning rod—a ball in the center of the cap and then a rod coming out of the ball.

For the globe, start at the top with Cadmium Orange + Venetian Red and come down a little to the left side and to the middle.

13. FINISH THE GLOBE

In the unpainted area of the globe, place some Cadmium Orange + Cadmium Yellow Medium. Blend this color to the left so there is no definite line between the two colors. On the left side, pat in a bit of Raw Umber over the red to create a shield over that side. Also pull this dark color across the entire bottom, again softening the colors together so there are no hard lines.

14. CONNECT THE CAP WITH THE BASE

Paint the dark section under the globe with Raw Umber + Paynes Gray. Be sure to continue the slight curves in this section so it conforms with the curve in the cap. Use the twiggy liner brush to place three brace bars that connect the cap to the base. The one on the right doesn't show much because the light knocks it out. Also place a small line of Brilliant Yellow Light on the bottom edge of the cap.

15. PULL THE LIGHT BEAM FROM THE GLOBE

Use the detail flat brush to pull the light beam out of the globe. Put a rather thick dab of Brilliant Yellow Light against the right edge of the globe. Then use the flat of the brush to pull out the dab. You can move the brush back and forth horizontally. Light does not stop abruptly so let the color fade away.

It is easiest to let everything tack up and then add the beam of light. If you lose too much of the Brilliant Yellow Light against the globe, place another thick dab there. You really want that area in the globe to be bright.

16. PLACE THE RAILING AROUND THE LIGHTHOUSE

Use the twiggy liner brush and Paynes Gray + Raw Umber to paint the railing around the lighthouse. Place the brush about ⅛ inch (3mm) from the bottom of the collar then pull straight up for a railing. The railings are just a touch shorter than the top of the collar.

Place the two side railings first. Then place the three railings in the center with Titanium White so they show against the dark background. Place the connecting bars between the railings with the dark mix. Any area that is in the dark is highlighted with Titanium White. Be sure these bars are slightly curved. You'll see just a bit of the backside of the connecting bars where it curves back into the collar.

17. PAINT THE LIGHTHOUSE TOWER

Switch to the detail flat brush to paint the tower. The tower is the same colors as the buildings: Titanium White + Paynes Gray + touches of Alizarin Crimson + touches of Ultramarine Violet. Use enough medium to make the paint move. Use the flat of the brush and pat on the paint with small, downward strokes. Do not use horizontal strokes that pull across the tower. The downward patting strokes help create the look of bricks.

The colors will vary. Be sure to start out lighter on the right side. As you move across to the left side pick up more Paynes Gray and Raw Umber. The tower is quite dark on the left side. You will create enough contrast that the tower will look like it's made of bricks, but you won't place any actual bricks. Adjust your colors back and forth enough to create contrast and the look of smudged brick. Make sure there is enough contrast between the tower and the background trees.

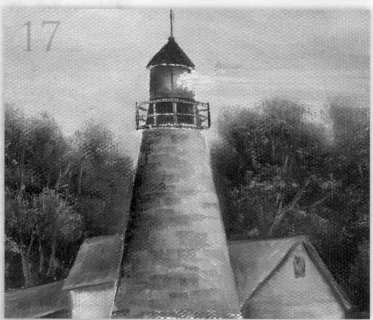

18. ADD THE NEAR PINE TREES

Base the large pine trees on the left with the small background brush and a dark mix of Paynes Gray + Raw Umber. Start by painting two vertical lines so you know where the centers of the trees will be then tap outward to create branches. Use medium to help move the paint on the canvas. The trees run together at the bottom but separate toward the top.

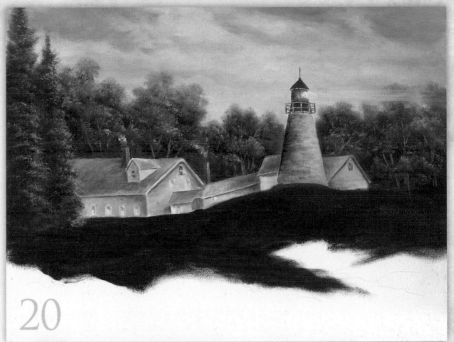

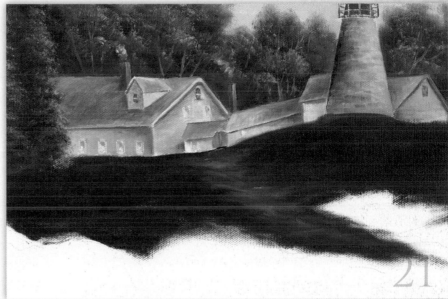

19. HIGHLIGHT THE TREES

Use the foliage fan brush to highlight the trees. Mix Viridian + Titanium White and load this color on the corner of the brush. Make the edges of the trees the brightest and then fade the color back as you move across the trees.

In the area near the building's windows, add a touch of Cadmium Yellow Medium to the highlight color so it looks like the trees are catching light from the windows.

20. BASECOAT THE FOREGROUND GRASS

Use the small background brush to basecoat the foreground grass. Paint down to approximately where the rocks start with the dark mixture of Paynes Gray + Raw Umber from Step 18. Use a little medium with the paint so it goes on dark, but not thick. Paint out the path.

21. ADD THE PATH

Brush in the path by picking up Titanium White + Paynes Gray + French Ultramarine Blue. Make sure the color is light enough to show up against the dark grass. Use small, sweeping strokes to create the path. It's not a distinct, well-defined path but it should end at the door of the building.

22. ADD SOME GREEN GRASS

Use the small background brush to add just a little bit of green grass with Viridian + Titanium White + an occasional touch of Cadmium Yellow Medium. There should still be a lot of dark showing through. Follow the contour of the ground and scrub out any hard edges. When you paint the grass near the windows, be sure to add more Cadmium Yellow Medium to the mix.

Switch to the detail flat brush and add streaks of Cadmium Yellow Medium directly beneath the windows. Then highlight the streaks with more Cadmium Yellow Medium and Brilliant Yellow Light.

23. CREATE THE FORE-GROUND ROCKS

Block in the rest of the ground with Paynes Gray + Raw Umber. Use medium to move the paint on the canvas. Add a little more grass if you desire.

Place the rocks with some blue-grays (Titanium White + Paynes Gray + Ultramarine Violet). You're really seeing more of the tops of the rocks than anything else. Make big tops and place only a little color on the sides. Use large strokes but don't lose all the dark.

24. ADD TREE TRUNKS AND FLOWERS

Place some tree trunks under the large pines on the left using the detail flat brush and the limb mix from Step 5. Then add a few subtle flowers in the grass with the foliage fan brush and Ultramarine Violet + Titanium White. Keep the paint on top of the fan brush and use downward flicks of the brush to place these flowers. You can place a few flowers around the rocks as well, if you wish.

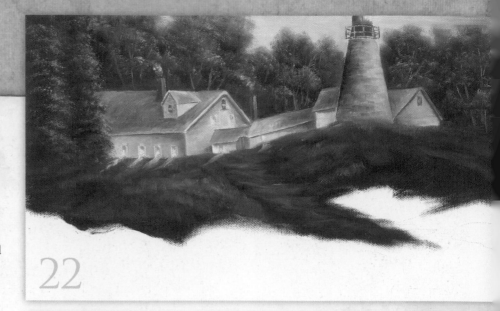

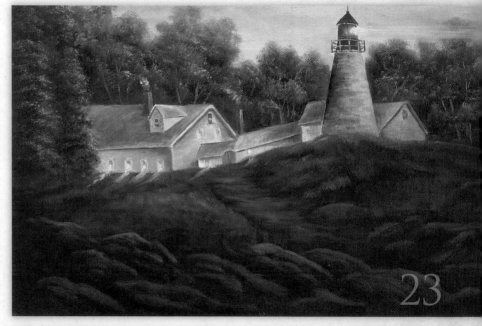

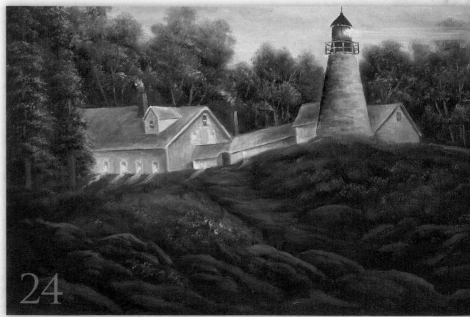

25. CHECK FOR PROPER CONTRASTS AND VALUES

Look over the painting and make any value adjustments or touch-ups as needed. Your values will look different when all of the darks and lights are placed and the canvas is completely covered. Here, I darkened the buildings a little more because they looked too light compared to the finished grass and rocks.

HIGH COUNTRY GRANDEUR

Palette knife paintings are fun to do. If you want to loosen up, give the knife a try. This little scene is not extremely detailed so it is a great place to start if you have never done knife work.

You will want enough paint on the knife to move it around, but not so much that you get bogged down in a lot of thick paint. If you put something on that you don't like, or you overwork an area, you can simply scrape it off and begin again. Highlights are laid on with a light touch. The important thing is to have fun painting. Enjoy the process. Time will fly by, and your problems will be put on hold for as long as you have a painting in front of you and a brush or palette knife in your hand.

So many places we could go,
So many scenes to see.
Let's choose to go where mountains rise,
And wind blows cool and free.

Come on, let's hike up to the top
Far up where eagles fly.
We'll look down on the clouds below
So lucky—you and I.

D. Dent

This pattern may be hand-traced or photocopied for personal use only. Enlarge first at 200% and then at 104% to bring it up to full size.

Materials List

Surface
Stretch canvas, 12" × 16" (30cm × 41cm)

Other Materials
Palette knife

Paper towels (to clean the knife)

MARTIN/F. WEBER PROFESSIONAL PERMALBA ARTISTS OIL COLORS

Alizarin Crimson

Cadmium Orange

Cadmium Red Light

Cadmium Yellow Medium

Cobalt Turquoise

French Ultramarine Blue

Titanium White

Viridian

Seeing With the Artist's Eye

I love to work with a palette knife because I enjoy the texture and looser look. This is a simple painting, but a good one to start with if you have done little or no knife work. The mountains are balanced by the dark pines in the foreground and middle ground. They should be very dark in value so they will look like they are in front.

The little yellow and blue flowers create more interest and color in the painting. If they were left out, the painting would not be as nice.

It is important to judge the size of the trees in a scene like this one. Be careful not to make far-away trees too tall. Distant trees will not look so much like trees as just darker texture on the mountains.

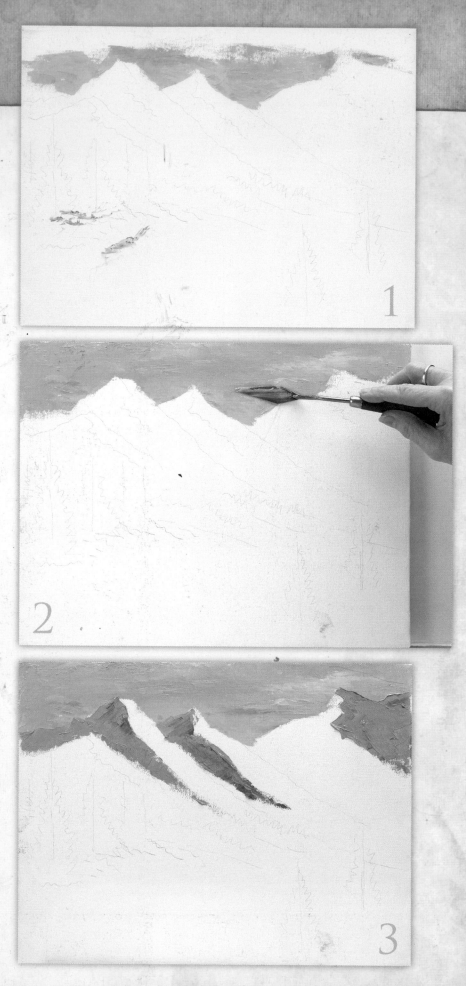

1. PLACE THE YELLOW SKY

Mix Titanium White + Cadmium Orange + Cadmium Yellow Medium to create the light sky color. Scrape in the color along the mountains. Add a small touch of Cadmium Red Light to the mix as you move toward the top of the canvas and away from the light of the sky. When you put the paint on the canvas with the palette knife use the side of the knife and pull down, then you can use the flat of the knife to move the color around. Move the knife any way you need to as you apply the paint. There is no right or wrong way to hold the palette knife.

2. PLACE THE BLUE SKY

On your palette, make a pile of Titanium White and add French Ultramarine Blue to it. Add a small touch of Cadmium Orange to the mix to gray the blue a bit. Then place this color at the top of the sky, scraping it on the canvas. As you come down over the orange you'll pick up some of the color and the blue will tone down a bit, which is fine; just work the colors together.

You may need to wipe your blade and pick up some of the original orange mixture to go back over the blue so you don't lose too much of the light color. You can also scrape some of the paint off at times if it feels too heavy. Thinner paint will blend easier.

Work the oranges and blues back and forth until you get an arrangement you like.

3. PAINT THE DARK SIDES OF THE MOUNTAINS

Mix Titanium White + French Ultramarine Blue + a touch of Cadmium Red Light. Paint the shadowed side of the mountain with this color. The light will come through the dip between the center mountains, so the left sides of the mountains to the left of the dip are darker, and the right sides of the mountains to the right of the dip are darker as well.

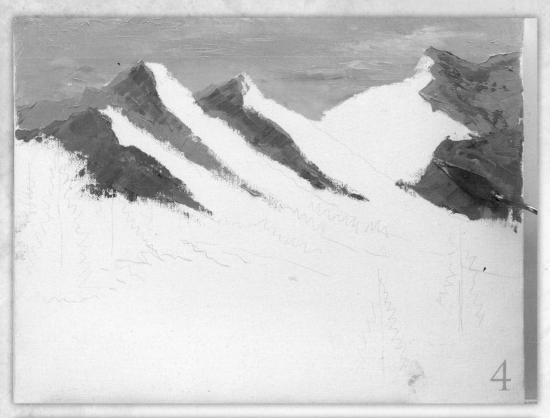

4. ADD CONTRAST TO THE MOUNTAINS

The left slope of the mountain farthest to the left is a bit darker than the other dark slopes, so add more French Ultramarine Blue and Cadmium Red Light to the mixture from Step 3. Also add this darker color on the far right side of the canvas.

As you work with this darker color you can place the color over the other slopes to add contrast. Be sure to move your knife with the slope of the mountain.

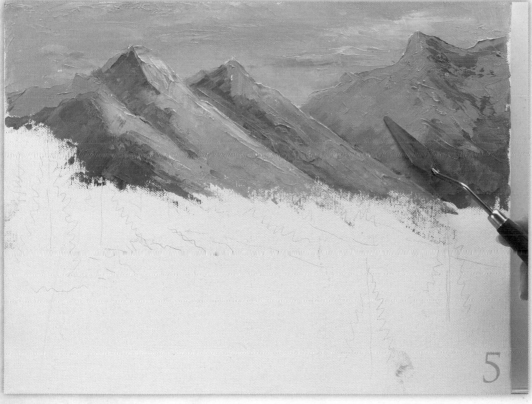

5. PAINT LIGHT SIDES OF THE MOUNTAINS

To paint the light sides of the mountains add more Titanium White to the mixture from Step 3 and add a touch of Cadmium Orange to dull the blue and create a brownish blue color.

Where the mountains meet in the dip add a bit of the darker color to the lighter right-side slope to create contrast and separate the two mountains.

6. ADD MORE CONTRAST TO THE MOUNTAINS

Take your basic lights and darks and add additional contrast where needed on the mountains. Mix Cadmium Orange + Titanium White and sometimes use just pure Titanium White. The lighter color can look like snow. For the darks add more French Ultramarine Blue to your mountain mix color from Step 3.

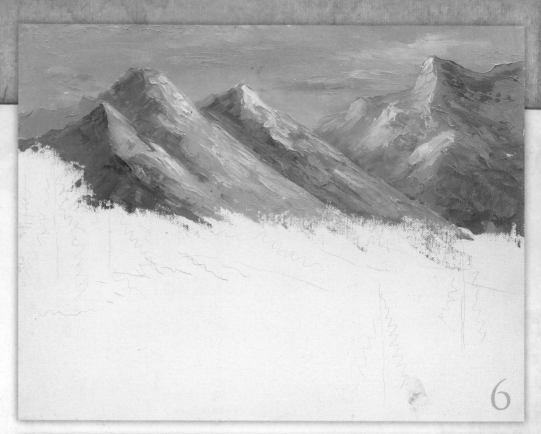

7. APPLY GREEN TO THE BASE OF THE MOUNTAINS

Work in a little more of the mountain blues (both the light and dark) in the area just below the mountains. Then mix Cadmium Yellow Medium + French Ultramarine Blue + Titanium White + a touch of Cobalt Turquoise to create a green. Pat this color in with the side of the knife. You're not shaping trees in this step; you're just adding green to the mountains. Make your strokes with the side of the knife and cut downward so you get a choppy texture. Let the green intermingle with the blue. If your mixture looks a little too bright or too dark put a little of the blue mixture from the mountain over it to tone it down. This green goes across the entire stretch of mountains so you will wipe out the pine tree pattern lines. Where you know those trees will be, scrape the paint off as much as possible so there isn't a buildup of paint in that area.

8. PLACE THE DISTANT TREES

Mix French Ultramarine Blue + a touch of Cadmium Yellow Medium + a touch of Cadmium Orange to create a dark, dull green. At the foot of the mountain, tap in a few distant trees that are taller. Tap the tip of the blade to the canvas and make an upward flick to create the tree shapes. You want a soft, messy look. Don't make the shapes too defined.

9. FINISH THE FOREGROUND

To finish the foreground add lighter greens in the middle-value and darker-value greens at the bottom of the mountains. Start with Titanium White + Cadmium Yellow Medium + French Ultramarine Blue. The lighter the green you want, the more Titanium White and Cadmium Yellow Medium you will use in the mix. For the darker green add more French Ultramarine Blue and maybe even a little Alizarin Crimson. Also vary the greens by adding touches of Cobalt Turquoise and Viridian to brighten the color. The greens should have a lot of variation to create a textured look.

Don't just smooth the color out. Use choppy, bouncy strokes that add texture and various colors. Long, sweeping strokes blend the colors together too much, and you don't want an overworked look. This is a knife piece and you want lots of texture.

10. PLACE THE FOREGROUND TREES

If there is a lot of heavy paint in areas where the large trees will go, scrape off some of this paint. The canvas doesn't have to be scraped clean, but removing a little of the paint will help the tree color application.

Make a very dark black color from French Ultramarine Blue + a touch of Cadmium Yellow Medium + Alizarin Crimson. Load the paint on one side of the knife and then set that side of the knife against the palette to make a line as shown in the first picture on this page.

Then move the point of the knife back and forth over the line to create the shape of the tree, as shown in the second photo on this page.

Then use the knife to scrape out a bit of trunk and some limbs here and there within the trees.

After the trees are in, tap some darker values beneath them for shadow and to make them look more set in to the painting.

Add a bit more Cadmium Yellow Medium + Titanium White highlights to the center of the grass.

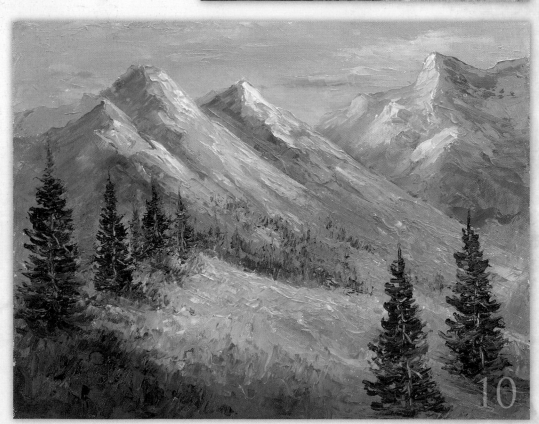

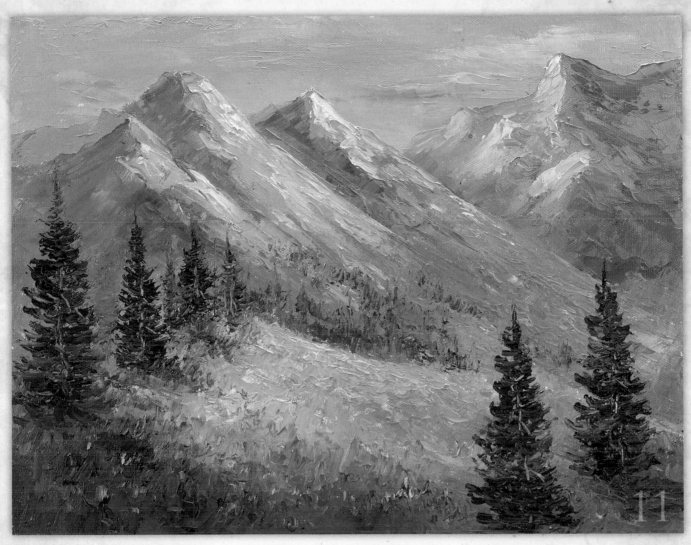

11. ADD THE FLOWERS

As you approach the end, look over the painting and see if you want to add more highlights or shading.

Last, paint the flowers using French Ultramarine Blue + Titanium White and some Cadmium Yellow Medium + Titanium White. These are just touches of color made with a patting stroke using the tip of the knife. Don't place them carefully or they will look stiff. Tap them on loosely and at random using a lot of color so they show up.

RESOURCES

U.S. RETAILERS

DecoArt, Inc.
P.O. Box 386
Stanford, KY 40484
Telephone: (800) 367-3047
www.decoart.com

Dorothy Dent
Painter's Corner, Inc.
108 W. Hwy 174
Republic, MO 65738
Telephone: (417) 732-2076
www.ddent.com

Martin/F. Weber Co.
USA and International
(Except Canada)
2727 Southampton Road
Philadelphia, PA 19154-1293 USA
Telephone: (215) 677-5600
www.weberart.com

CANADIAN RETAILERS

Folk Art Enterprises
P.O. Box 1088
Ridgetown, ON N0P 2C0
Phone: (800) 265-9434

MacPherson Arts & Crafts
91 Queen St. E.
P.O. Box 1810
St. Marys, ON N4X 1C2
Phone: (800) 238-6663
www.macphersoncrafts.com

Martin/ F. Weber Co.
Canada
26 Beaupre
Mercier, Quebec J6R 2J2
Telephone: (866) 484-4411
www.weberart.com

INDEX

THE BEST IN ART INSTRUCTION IS FROM
North Light Books!

PAINTING LANDSCAPES FILLED WITH LIGHT

Capture the rich, elusive properties of light! In 10 step-by-step projects, Dorothy Dent shares her easy-to-master techniques for painting light-filled landscapes in different seasons, weather conditions and times of day. Dorothy's projects include oil and acrylic painting demos, with advice for adapting the technique used for one medium to that of the other. Prepare to be amazed by the landscapes you create!
ISBN-13: 978-1-58180-736-3, ISBN-10: 1-58180-736-8, paperback, 144 pages, #33412

JERRY YARNELL'S LANDSCAPE PAINTING SECRETS

Follow along as popular PBS host Jerry Yarnell shares his favorite techniques for painting a variety of landscape elements. After instruction on materials, color mixing, values and other general painting techniques, you'll learn to paint water, land, trees, skies and more. Then, take your paintings to a whole new level as you put your newly acquired skills to use to create lovely snow scenes, waterfalls and more.
ISBN-13: 978-1-58180-951-0, ISBN-10: 1-58180-951-4, paperback, 144 pages, #Z0660

ACHIEVING DEPTH & DISTANCE

Achieving Depth & Distance helps you paint realistic landscapes by showing you the right colors, values and textures to express near, middle and great distance. Ten step-by-step oil painting demonstrations on canvas teach you how to paint a wide variety of subjects, scenery and seasons with a convincing depth of field. Colorful diagrams, reference photos and eye-catching side-by-side comparisons make it easy and fun to learn these important techniques.
ISBN-13: 978-1-60061-024-0. ISBN-10: 1-60061-024-2, paperback, 144 pages, #Z1308

PAINTING PEACEFUL COUNTRY LANDSCAPES

Experience the joy and satisfaction of painting your own charming country scenes with this complete step-by-step guide. The 10 start-to-finish painting demonstrations teach you to paint a range of realistic pastoral scenes, from dancing waterfalls and mountain pines to fragrant fields and rolling farmland. You'll find both oil and acrylic painting demos with a handy color conversion chart that lets you work in the medium you're most comfortable with.
ISBN-13: 978-1-58180-910-7. ISBN-10: 1-58180-910-7, paperback, 144 pages, #Z0608

These books and other fine North Light titles are available at your local arts and crafts retailer, bookstore or from online suppliers. Visit our Web site at www.artistsnetwork.com.